the lay of

the land

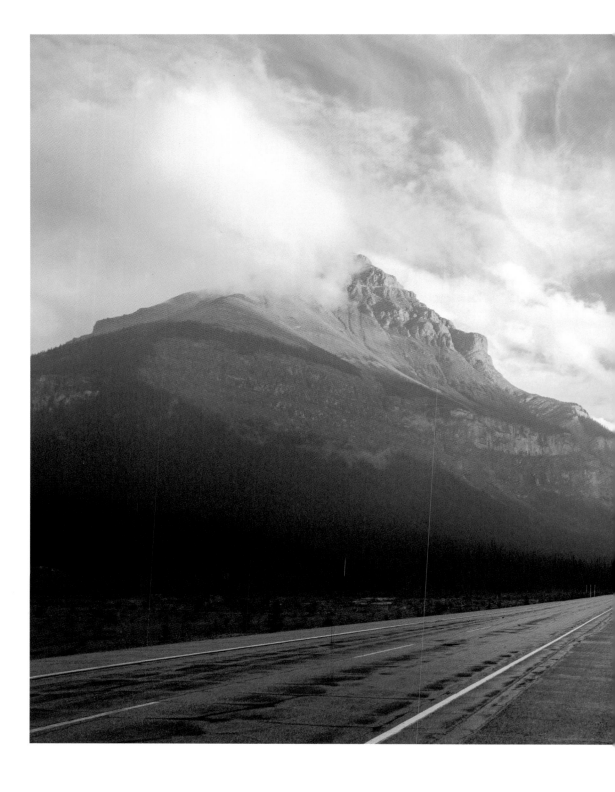

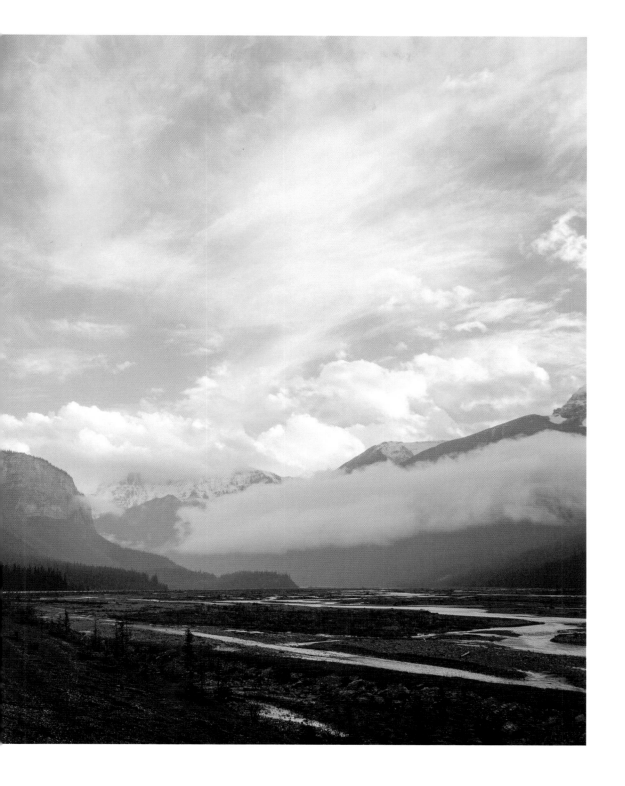

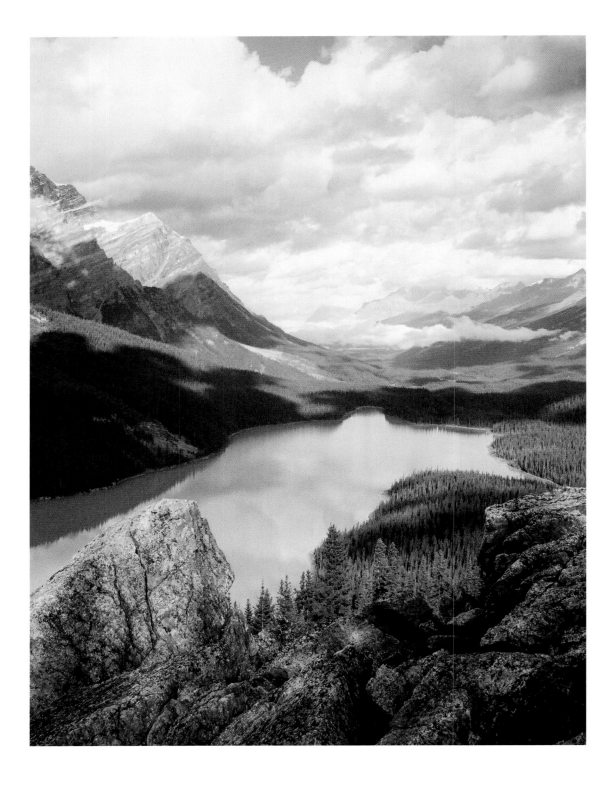

the lay of

the land

A SELF-TAUGHT
PHOTOGRAPHER'S
JOURNEY TO FIND
FAITH, LOVE,
AND HAPPINESS

joe greer

An Imprint of HarperCollinsPublishers

for my mother

to madison and
hannah

Book design by Amanda Jane Jones

First published in 2022 by
Harper Design
An Imprint of HarperCollins*Publishers*
195 Broadway
New York, NY 10007
Tel: (212) 207-7000
Fax: (855) 746-6023
harperdesign@harpercollins.com
www.hc.com

Distributed throughout the world by
HarperCollins*Publishers*
195 Broadway
New York, NY 10007

ISBN 978-0-06-311178-3
Library of Congress Control Number:
2021038981
Printed in Malaysia
First Printing, 2022

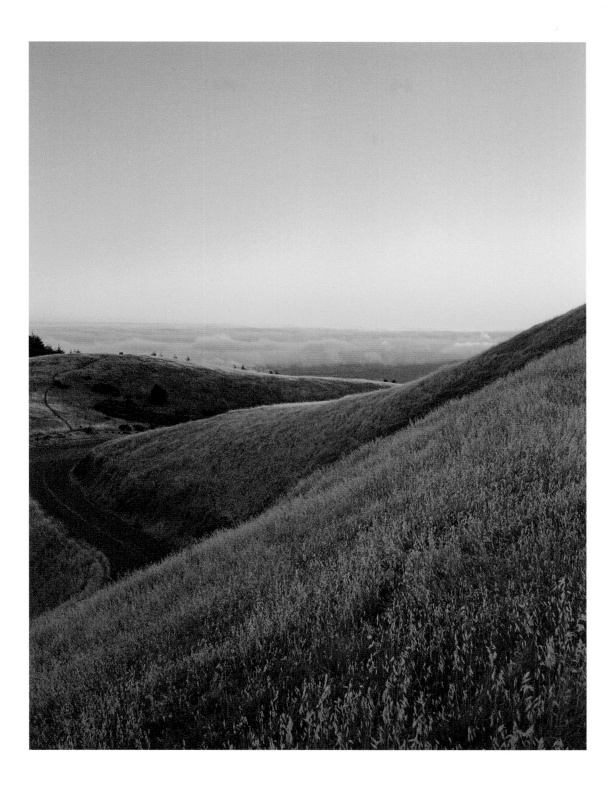

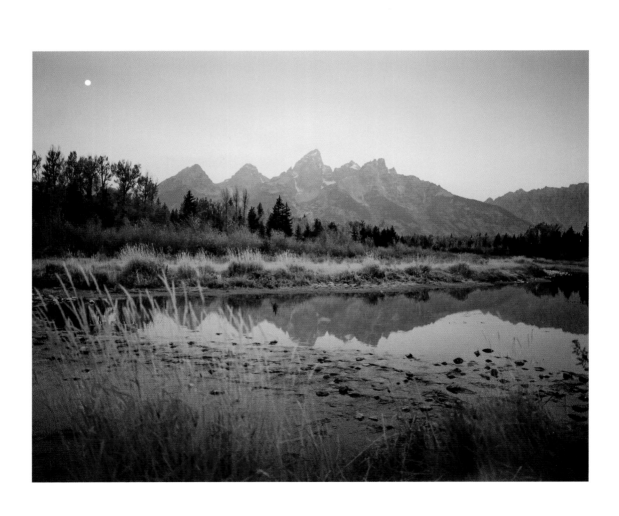

contents

introduction

CLICK.

It takes less than a second to line up the shot and press the shutter. By this point the act is so reflexive, it's like muscle memory—but each time I do it, the moment feels sacred.

Never in my wildest dreams could I have imagined that I would become a photographer. Seriously, making pictures for a living? It's a crazy thing to be able to follow your passion, and that's what photography is for me—more than a paycheck, a way to provide for my family. It is a way of life. Photography has become the way that I communicate. The way I go about telling a story is in large part by shooting intimate moments that I hope will stand the test of time. Photography is so much more than "point and shoot" or uploading to Instagram, or using X number of hashtags. It's another chance to see the world unfolding before me, to find a way to capture that magic.

Photography can act as a time capsule, allowing you to revisit some of the most beautiful moments of your life. I'll never forget the first picture I saw of my wife, Madison—before she was my wife, before I'd even *met* her—and immediately felt the first pangs of love. I'll never forget the first pictures I took of our land in Tennessee, where we'll build our home and start a family, because those pictures represent all of the moments that brought me to where I am today.

If you'd told the college kid who had just started snapping photographs on his iPhone that he would one day be sharing his journey online and traveling the world making photos— well, he would have laughed in your face. Not with unkindness, but in pure disbelief. I never expected to have any kind of online following, or to be able to make a passion into my profession.

When I started, shooting landscapes was just for fun—a good way to get me to forget the difficulties I was experiencing, and the trauma I was working really hard to overcome. Making photographs gave me a break from that, and it also instilled a sense of hope. Because the way I learned to tell my story was originally through landscape and travel photography, that is what you'll see in this book.

My past is complex, and the older I get the more I embrace all of its hard and messy truths. I find myself becoming more nostalgic as the days add up, constantly reflecting on all the unexpected and unlikely moments that perfectly aligned for me to be where I am in my life. Even the worst of my heartbreak and tragedy directly affected, and continue to have its effect on, my work. The way I see when I am behind the camera, the ways I see other people. It's those experiences—the good, the bad, and the ugly—that taught me to constantly recalibrate. To—when the going gets tough—just take a deep breath and, before doing anything else, reassess. Look with fresh eyes at what's in front of me, and then get the lay of the land.

I like to say that I *make* my photos, and what I mean by that is photography is dynamic. When you get out there and shoot, you're not just taking a picture. You're *making* a memory. You're telling a story. I first heard the phrase through Joel Meyerowitz, and I immediately loved the precision of it, loved how it gave meaning to the act and seemed to slow down the process itself.

Ultimately it's you, the photographer, who can bring images to life. We are at the mercy of the elements, natural light, energy of the streets, or the mood of our models when photographing. So it is up to you to find the magic and then make that moment when it presents itself.

Whether you have been following my photographic journey for years or were given this book by a friend, I am beyond thrilled to let you in a bit deeper. To share with you the ways in which I believe photography has the power to change the world, to become a vessel of healing for oneself as well as others. To show you how it has been those things for me. And it is my greatest hope that as we go through this journey together these landscape photographs I have made over the course of my career give you a sense of peace and liberty while stirring a new feeling of curiosity for this world.

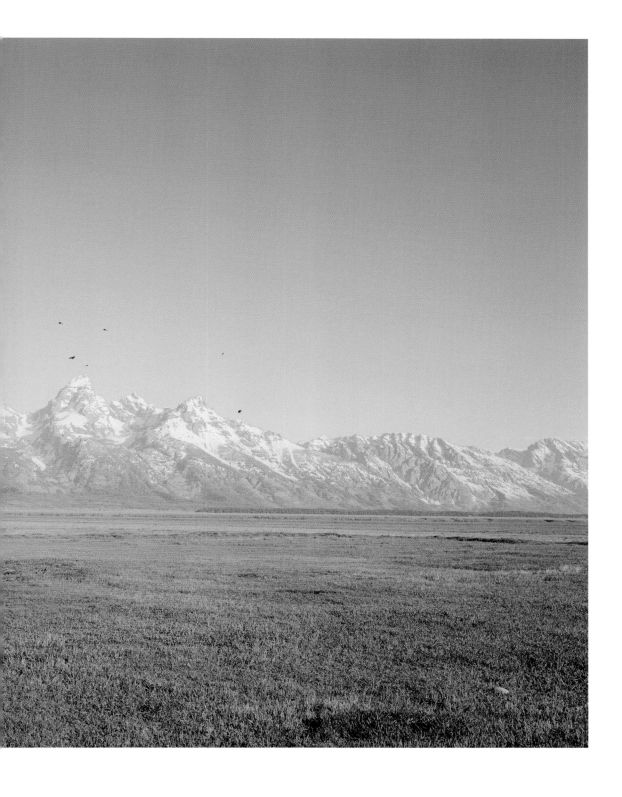

chapter 1

the early years

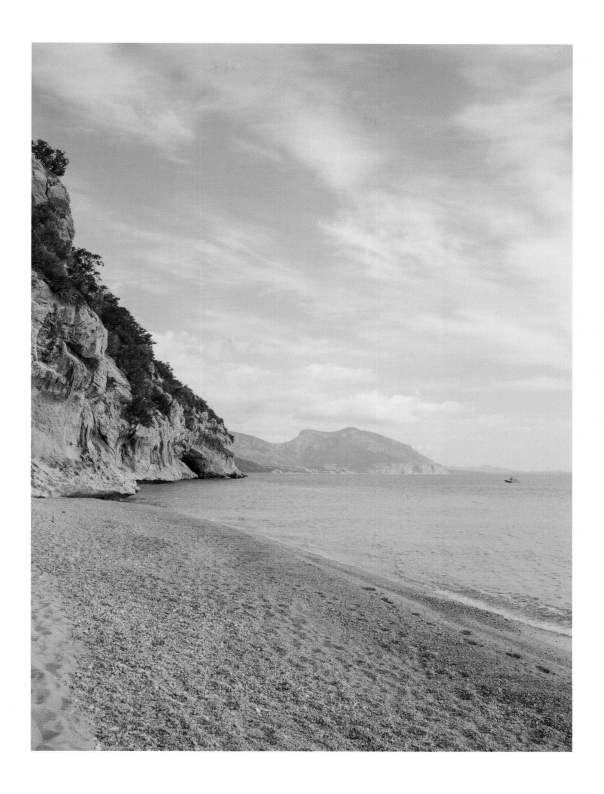

I WAS BORN Joseph Matthew DeKalaita, on February 17, 1989, in Flint, Michigan, to Nikkianne DeKalaita. The only son of a single mother. No father figure, which, as I was told, was exactly how my mother wanted it.

Those early years of my life, it was just the two of us—and we were close. I remember how she'd chase me around the halls or in the backyard of family gatherings over the summer, totally encouraging play. My mother was obsessed with Harley-Davidson. One Christmas she got me a little electric motorcycle for kids, and let me zip around the house on it. Another time I remember going into her bedroom late at night asking if I could have a glass of soda. She yawned and said of course, and so I poured the soda, brought it into bed, and then fell asleep snuggled up beside her.

On my fourth birthday, my relatives in Michigan threw me a little party at Chuck E. Cheese. There were games and it was a ton of fun, but weirdly, my mom didn't show up. I don't remember much else about the party, or that night; I just remember not seeing her, and waiting the following morning for her to pick me up. But my mother didn't show up the way she always did.

I later found out that she had met a couple of friends for a quick happy hour drink before the birthday party. But as she and her friends were heading from one bar to another, they asked a colleague to drive to the next spot. They had had a little too much to drink and didn't feel safe driving. The guy said he was okay to drive, but he wasn't—he ran a stop sign and, when he did, a passing car T-boned the passenger's side. Right where my mother was sitting.

By the time I found out what had happened the following day, she was still in critical condition, fighting for her life. The guy? He escaped unscathed, and later claimed that it was my mom who had been driving. Thankfully there were witnesses there at the scene who said that she'd been in the passenger seat. And a doctor could tell that the blood and injuries on the right side of my mother's body matched the blood on the right side of the car's interior.

When I was finally able to see her again, it was like meeting a different person. I knew within seconds that this wasn't the mother I had known. The crash had changed her completely. She couldn't walk, couldn't talk, and looked like she was fifteen years older. I remember going to see her at the hospital and nursing home, and in the beginning it was pretty uncomfortable—like meeting a stranger. She wasn't able to call me by my name anymore, couldn't stretch out her arms to hug me or chase me down the hallway like she used to.

We'd had such a dynamic relationship, but seeing that I was only four years old when she had her accident, there are only a small handful of memories I have of her.

...there are only a small handful of memories I have of her.

I remember that as a little kid I used to go to work with her to the auto shop she managed, a place called Rainbow Muffler. One time,

when she had to take a call, she left me in our car in the garage, and the mechanics were watching over me. While I sat in the backseat playing with my toys, the car just started lifting up.

Totally panicked, I looked out the window, teary-eyed. The mechanics were waving, and there was my mother laughing and telling them to get me back down right away. That was how she was, and how I remember her—the life of the party. Just so vibrant and energetic. I couldn't totally understand that the person I was seeing after the accident was the same person, that she was my mom—just a different version.

About two years after the accident she passed away from complications of her injuries. During those two years I didn't have any sort of stability, just bouncing around from household to household—one week with one relative, the next with another.

After her death, the court decided that I would stay with my aunt—my mother's sister—and uncle, who at the time had three kids, in Florida. The court felt my aunt and uncle were in the best place financially and structurally to bring in and raise another child, and doing so meant my cousins would now be my brothers and sisters: Nick, Jacob, and Rachel at first, and, later on, Hannah and Sarah. Moving in with them also meant when I was legally adopted my name was changed from Joseph Matthew DeKalaita to Joseph Scott Greer.

I was adopted into a Christian household. Even to this day, I joke that I was adopted on a Saturday and kneeling in a pew the very next morning. We actually lived next to our church, and went to services every Sunday and

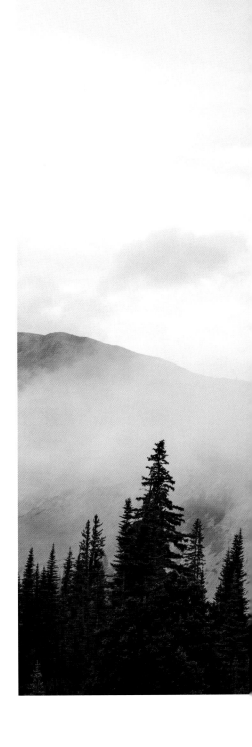

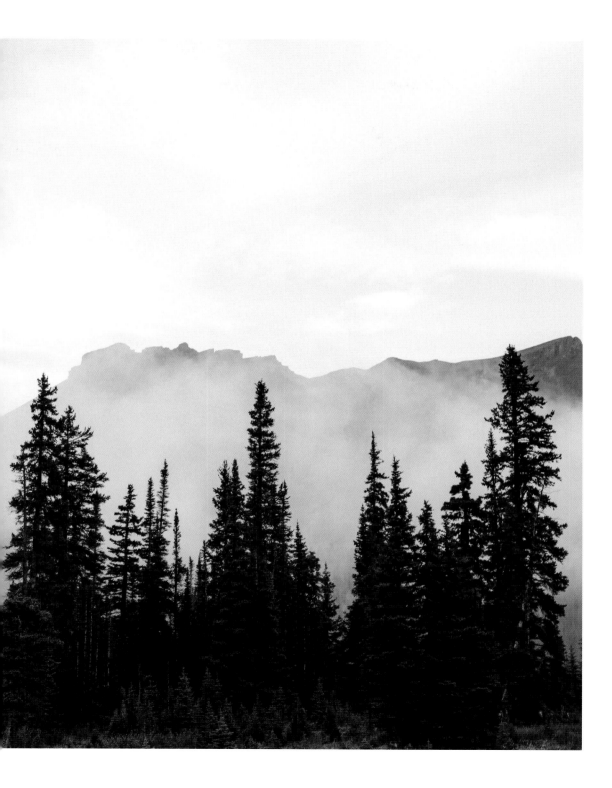

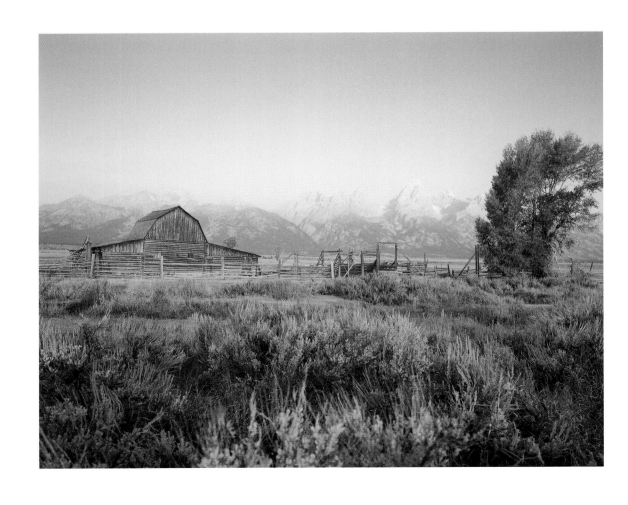

Wednesday. For the next fifteen years, church would prove to be a stabilizing presence in my life—and that kind of security was something I desperately needed. I know that isn't the case for a lot of people who grew up in the church, and that faith can prove to be part of a more complicated relationship. But for me, church and religion provided a safe haven during those incredibly transformative years. I had questions—lots of them. I went to God.

I had questions—lots of them. I went to God.

Some were questions about my own life: Why had my mother died? Why did the driver who hit her escape unscathed?

Some were larger, more existential in scope: Who is God? Why would an omnipotent God care about, well, *me*?

I would get so wrapped up in the magnitude of those questions I wound up wondering how much God could really care for me. I knew that there had been about 108 billion humans who had lived, died, or were still living on earth. 108 billion! How could there be a God, I wondered, who knew and *wants* to know and love all of those humans? How could He see me with such an expansive world before Him?

I wrestled with those thoughts for a while. I was young, traumatized, and confused. So much of my life felt opaque, like I was looking at it in a clouded mirror. I'd lost my mother, never known my father, and moved into a home where I knew I looked different from my

adopted family and my new siblings. Much as I loved them, there was a whole other life that I could have had—one that on some days didn't feel so far out of reach. I wondered what it would have been like to grow up with my mother, to have actual blood siblings. I thought about her quite a lot, and how our relationship would have evolved.

Thinking like that—wondering what my life could have looked like, wondering why it looked the way it did—just made me feel alone. And even though I could hide that sadness from the people around me, I couldn't truly hide it from myself. I kept going to church, I kept asking questions, but of course I still wondered about what my life could have been.

I'm sure that the suddenness of losing my mother and the far-reaching effects of trauma have impacted what I can remember about her, which is a challenge. While as a kid I didn't think about how the effects of trauma might have impacted my memory, I'm sure they did. I'm grateful for what I have, I just wished—and still wish—for more.

My aunt never really talked about my mother, her sister. I didn't understand why—though I had my theories. Maybe because losing her baby sister was too difficult for her to talk about. Maybe she was worried with how it would affect me bringing her up? Maybe it was a bit of both, or neither. I don't know.

Outside of going to church, my childhood in Florida was sheltered. My adoptive parents—and especially my aunt—have even said they felt like they needed to be more strict with me than with my other siblings. While they never said why, exactly, I always felt like this was because they didn't want what happened

to my mother to also happen to me, and were afraid that the drinking life my mother lived was a struggle I could face. Which is likely the reason that while growing up we kids never saw a drop of alcohol in the house. Not one.

So aside from going to school, church, cross-country and track practice, I was at home. I sincerely believe that this kind of upbringing left me absolutely thirsty for the outside world. That's how my mother was, too, forever chasing new experiences. As a kid, I was the same way; I was curious about new things, new ways to see the world, new kinds of experiences, always looking to find beauty outside of our tiny 1,300-person town of Inglis, Florida, north of Tampa near the Gulf Coast.

I had glimpses of what the world outside of Inglis was like, most memorably at camp. Every summer, from when I was six to twenty-one, I went to Bible camp—and man, I loved it. Summer camp was my escape. Whether it was the opportunity to meet other kids, or find adult role models, through the years I saw so many facets of human experience there. Like how typically the younger kids cry when their parents drop them off, and the older kids just sprint off to find their friends— sometimes even forgetting their bags in the car! For many young kids, summer camp is likely their first time staying away from home, and a week away can be daunting.

I was the opposite.

When I was younger, I was the kid who cried when I had to *leave* at the end of the week. Camp came to represent freedom and adventure. Those were things that felt foreign to me growing up in Inglis, but that I knew I wanted. Not to mention that camp also gave

At a young age, I'd been gifted a curiosity that would last a lifetime.

me a sense of home, and a security that I'd been searching for. There were all kinds of adult role models—the nurse, who was always happy to talk to me and offer a popsicle, even though I never actually fell sick; the camp cook, who was also from Michigan, and made a point to check in on me; the camp director and her family, who also became huge spiritual influences.

Those questions I'd had as a little kid were still present. Back at home in Inglis, I wondered what the outside world was like, and why my world was the way it was. But camp showed that one day it *could* be different.

Still, that secluded childhood is a big reason why I find so much joy and beauty in exploration, as well as the daily mundane things we encounter as humans. While those years were at times extremely painful, they gave me a curiosity and drive that I may not have otherwise known. At a young age, I'd been gifted a curiosity that would last a lifetime, remind me to keep learning, asking questions, taking risks. I know I got that from my mother.

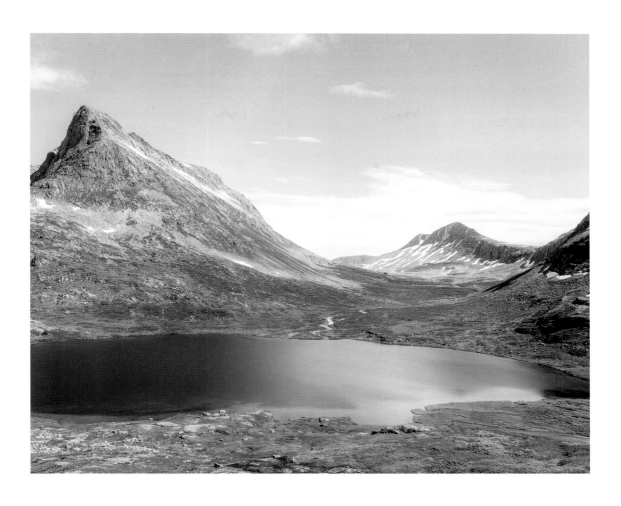

chapter 2

college

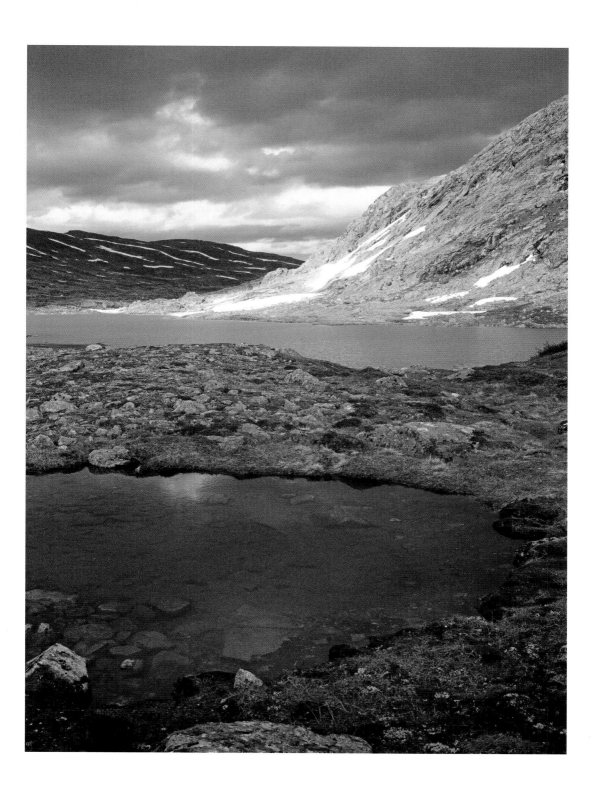

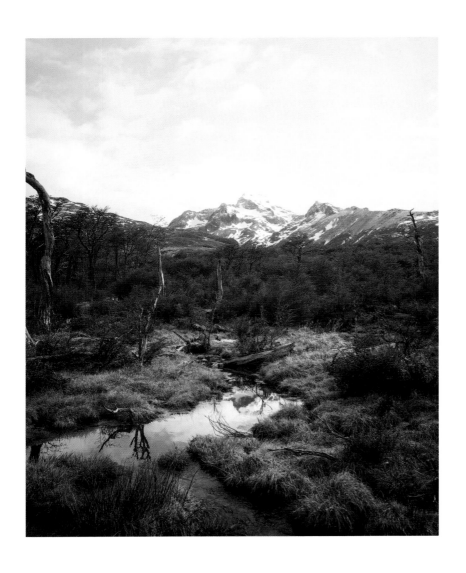

I DIDN'T WANT to stay in Florida forever—what I really wanted was to follow my passion. And in 2007, my senior year of high school, that meant running. I'd become a pretty competitive distance runner, and was planning to go to Liberty University in Lynchburg, Virginia, which had an excellent running program.

The months leading up to the big move to Virginia were a blur—busy, exciting, full of this buzzing hope for my future. I did all the regular things in preparation—packing my suitcases, figuring out all of the necessary paperwork—all the while dreaming about what my new life would look like. My aunt and uncle were excited to help me through the process, and it was my aunt who brought me to our local bank several different times over the course of the summer. Routine paperwork, they said. Not a big deal. I didn't think much about it.

My aunt and uncle paid for that first year of tuition and my books, all of that, which gave me freedom to pursue running. In a big way. That first year, I was able to walk on to the cross-country team. But as much as I still loved running, I was totally enraptured with

I wanted to be the life of the party, and I wanted to meet *everyone*...

the social life of college. Nothing wild, nothing crazy, but it was the first time I'd ever experienced the freedom of being on my own. Simply being surrounded by thousands of kids my age, and living more than ten hours away from

home without my aunt and uncle watching my every waking move—well, it was exhilarating.

Like my mother, I had an extroverted personality, which quickly started to show in social settings. I wanted to be the life of the party, and I wanted to meet *everyone*, so that's exactly what I did. Even when I went home for the holidays, I was itching to get back to Liberty. That was my new normal.

A year later, on Easter Sunday, I got a phone call from my grandmother. My mother's mom. It had been thirteen years since I'd heard from her, since I was adopted. I knew that my aunt and uncle had cut off all communication with that side of the family, but it had happened when I was so young, I couldn't really understand the reasoning, though of course I felt the absence.

I remember my nana being around a lot when I was younger. Whether it was her coming over to our house or us getting dropped off at her place and spending countless hours in her neighborhood pool, she made so much time for us. I didn't realize in the moment how special that was. She was splitting her time—seeing all of her grandchildren and then going to see my mom in the hospital every day.

After my mother passed away, though, I started to see Nana less and less. One of the last times I saw her was when I was seven, and she pulled me aside in my room to talk privately. She began to explain to me how she would always be there for me and if I ever wanted to come live with her to just say the word. To let her know and she would do everything in her power for that to happen. Soon after that, though, we stopped hearing from her, and I wasn't told why.

So when I heard her voice I was nervous, confused as to how she got my number, but also so excited to hear from her. In catching up, she asked a lot of the typical questions: "Where are you?" "What are you studying at school?" "How are your brothers and sisters doing?"

But then she flat out asked me: "Joe, so do you have your money?"

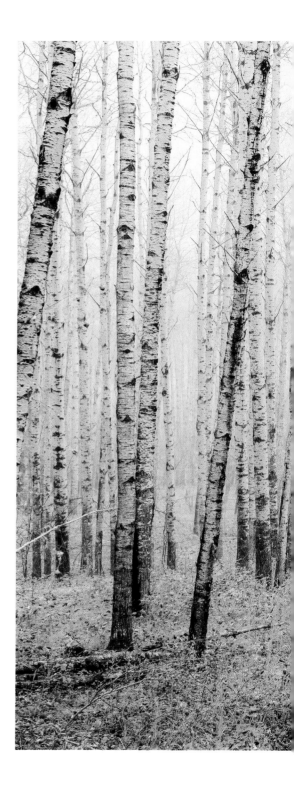

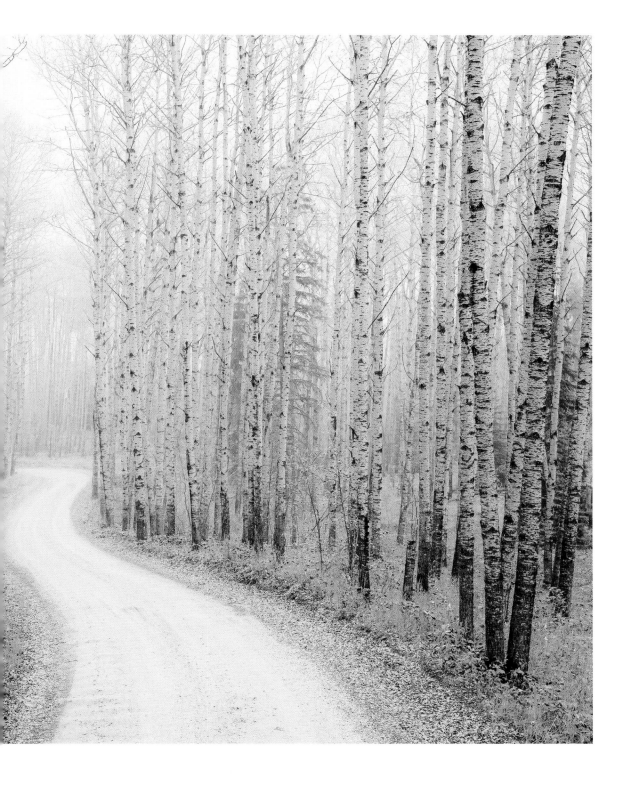

chapter 3

the money

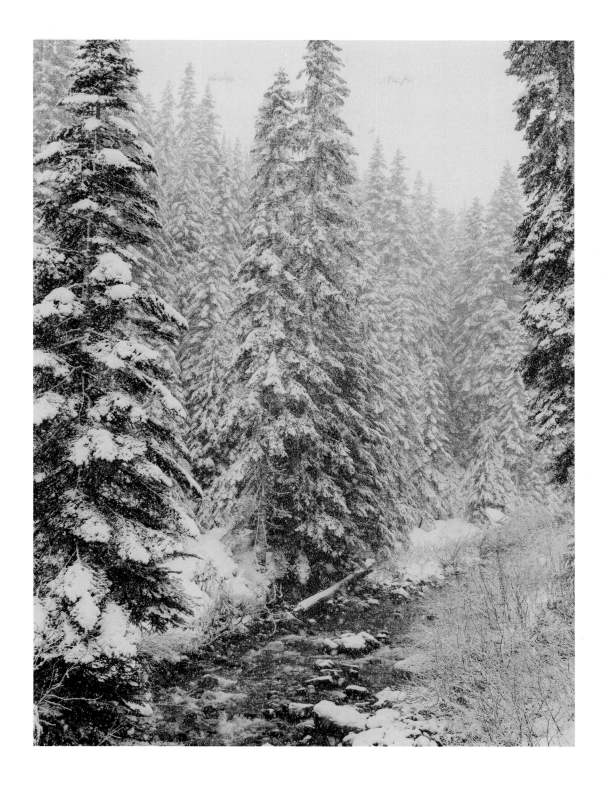

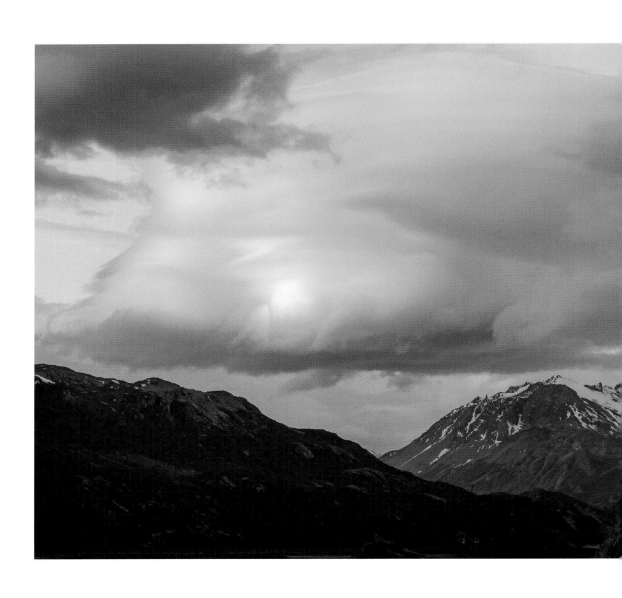

I'D VAGUELY KNOWN that there was money, but only because of my older brother, Jake. One day, when I was about twelve, we went hiking in the woods behind our house when he told me that I'd be getting money because of my mother's death. Jake said that basically a lot of money was set aside for me because of that, and when I came of age, I would get all of it. I just laughed it off and said, "Yeah, yeah. Right." I mean, I was twelve. I was more worried about which girl I was going to sit next to at lunch, than whether I'd get money when I turned eighteen. That already felt like a lifetime away. I figured I'd find out more before I turned eighteen, so there was no need to ask my adoptive parents anything about it just yet.

"Nana," I said, "I kinda know what you're talking about, but not really. Could you explain more for me, please?"

She was shocked and went on to explain to me in great detail for the very first time what had happened at the court settlement.

It turns out that my grandmother and aunt took the guy who killed my mother to court, and they sued him. I mean, they *really* went for it. During our call, my nana told me that a million dollars was set aside for my benefit. The court allowed such a big sum because I was left without a mother, when I already didn't have a father figure in my life. They hoped this money would help me in my new life when I was older. I'd never seen a penny.

My nana then said, "Joe, this doesn't make any sense, you're nineteen. You should have had this money already! Do you have any idea what could have happened? Did anything weird or odd happen when you turned eighteen?"

Anything weird? I didn't think so.

But then I thought back about the paperwork I signed at the bank before I started college. Could that have had something to do with it? Just weeks after signing that paperwork, my aunt and uncle bought a flower shop business and a few brand-new flower vans, all paid for in cash. My uncle bought a bunch of new heavy machinery for his business. Also cash. I didn't question any of that in the moment. I was just stoked for the family that there was a new family business, and I had college on the brain. (I still don't know what exactly I signed at that bank or what it had to do with the money.)

After hearing everything from my grandmother, I realized my aunt and uncle had no idea that I knew anything about the money—they had never even mentioned it to me. My nana, in finding this out, was stunned and angry. So was I, but I didn't know what to do.

The prospect of confronting my aunt and uncle felt daunting, even though it was inevitable.

There were a few reasons for my hesitation, the first being that my aunt and uncle were—and still are—very private people. Always have been. They have this presence about them that is strong, sturdy, and unwavering, a my-way-or-the-highway type of mentality. As a kid who was trying to process a new reality, while not fully understanding the isolating effects of trauma, I was scared to really ask anything of them—let alone confront them about something. Living with them was just different from living with my mother, or my nana, who were both very affectionate. My aunt, though I knew she cared about and loved me, rarely showed physical affection or verbal affirmations of love.

The other thing about asking them the question was that, eventually, there would have to be an answer. What if they said, yes, they had done that? Or what if they said it was a mistake? No matter what the answer was, I knew it would shake up my world, and potentially bring more trouble than good.

So I decided to wait on having that conversation until I felt strong enough and ready for an answer.

After that freshman year at Liberty University I went back to Florida. Ironically enough, Liberty was expensive and my aunt and uncle didn't want to pay for another year. With college no longer a possibility and without knowing what would come next, I was driven by a new desire: I felt led by God to pursue my faith further in education and strive to be a preacher or pastor of a church. Having grown

But to make the plan work, I needed money.

up in the church for almost my entire life, studying, memorizing, and learning the scriptures, had led me to this moment— I was sure of it. That could be a reason it hadn't worked out with Liberty.

But to make the plan work, I needed money.

Those next two years I lived in Florida working at the family flower shop and coaching cross-country and track at my old high school. The money was still on my brain, but saying something to my aunt and uncle still felt complicated. I didn't know what it would mean for my life if I took that leap, and after

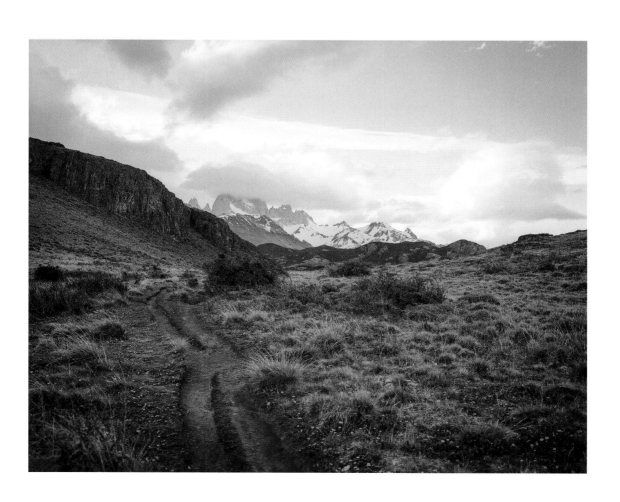

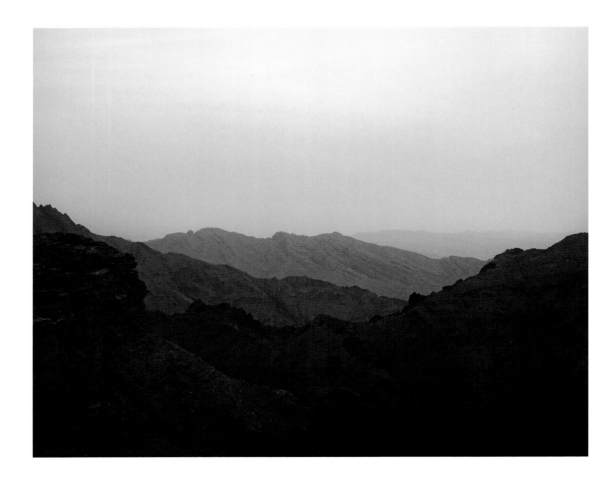

Liberty didn't pan out, I knew I needed to take control of my finances in order to make my next dream possible.

The answer, as it turned out, was camp. I became a head counselor, and started working there year-round as I considered next moves. One of my spiritual mentors at camp encouraged me to attend a Bible college way out in the Pacific Northwest: a place called Moody Bible Institute in Spokane, Washington.

The problem was still that I didn't have enough money to pay for all of it and my aunt and uncle weren't going to pay for any more school for me.

But there was one evening toward the end of that week, when the kids had an opportunity to share things they had learned or give a personal testimony about faith. I remember sitting in the very back of the chapel moved to tears by these middle schoolers' life experiences and how, after this week of camp, they felt closer to God.

It was in that moment where I felt my calling: to further my studies in the scriptures and go into some type of full-time ministry.

"Okay," I told my mentor, "but how do we make this work?"

As we talked about this and that, and how I might be able to afford college, I told him my story, about my mother's accident and the money I was supposed to have inherited. He strongly and lovingly encouraged me to confront my aunt and uncle about those funds, to say I had spoken with my nana and she had told me everything. He also encouraged me to try to locate some sort of legal documents backing the claims, so they couldn't dismiss what I was saying.

I knew then that, no matter how uncomfortable it would be, I'd have to have the con-versation. Even if it meant my aunt and uncle were livid, or that they never spoke to me again, that money meant a ride out of Florida, it meant I could go back to Liberty or even to the Moody Bible Institute. It meant I would have freedom to do whatever I wanted.

So a few weeks before I planned on talking to them, I waited until they fell asleep to go digging around for the documents. And sure enough, after hours of searching, I found a box containing court settlements, adoption papers, autopsy report, police report—basically, everything surrounding the accident and death of my mother was in that box. On the two-hour drive back to camp my head was spinning with questions. What would I discover? Would it give me peace or make me more angry? Would it help me to heal? Or would it cause more division? Whatever that box held, I believed that finally I would have some answers.

The following weeks would be emotionally draining.

Combing through the papers was difficult on a couple of levels: emotionally, of course, but also in trying to decipher all of the legal jargon. The single-wide trailer where I was staying at camp was covered in paper; I could hardly walk through the living room.

The more I read, the clearer it became that my grandmother was not making the whole thing up. The judge's order? A million dollars was set aside in my name. There were signatures, including my aunt's. My aunt was appointed trustee for the funds, which she was supposed to use to benefit me and our family.

Armed with that knowledge, I was finally ready to approach my aunt and uncle.

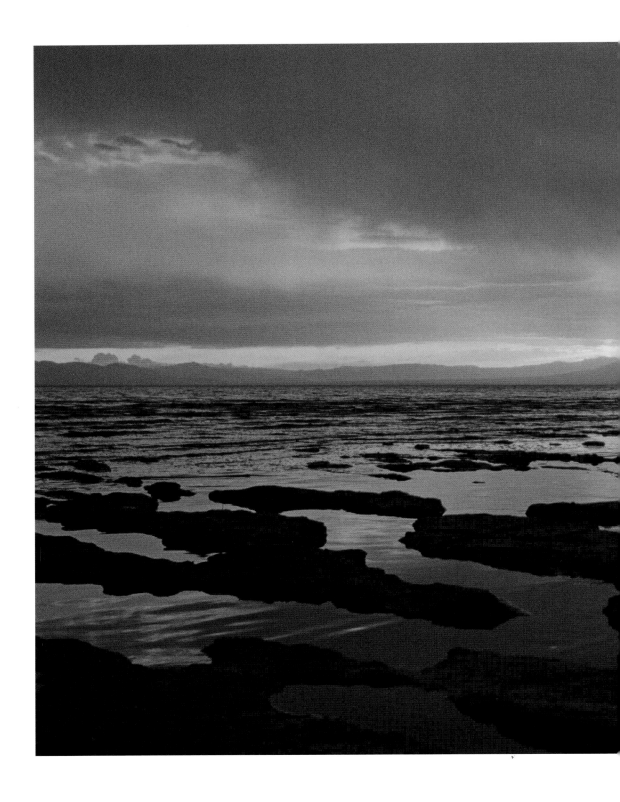

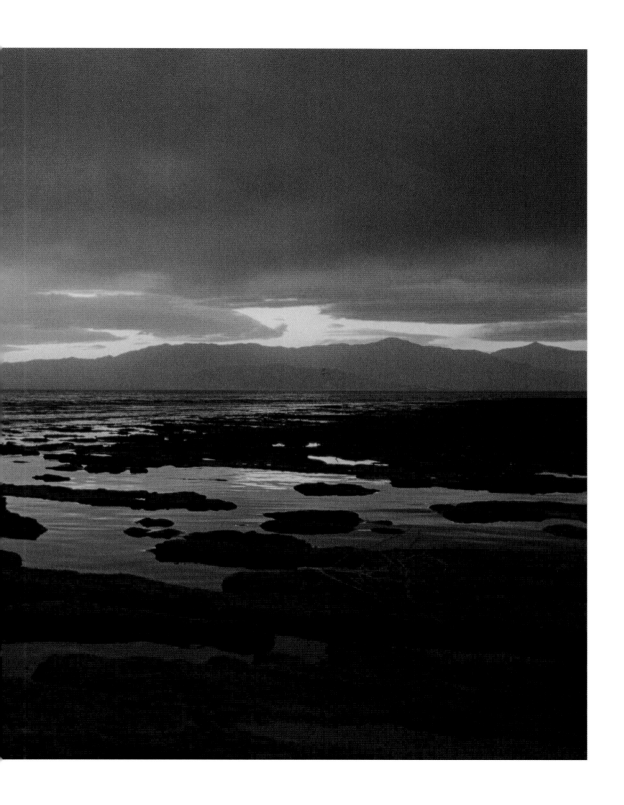

chapter 4

the conversation, 2009

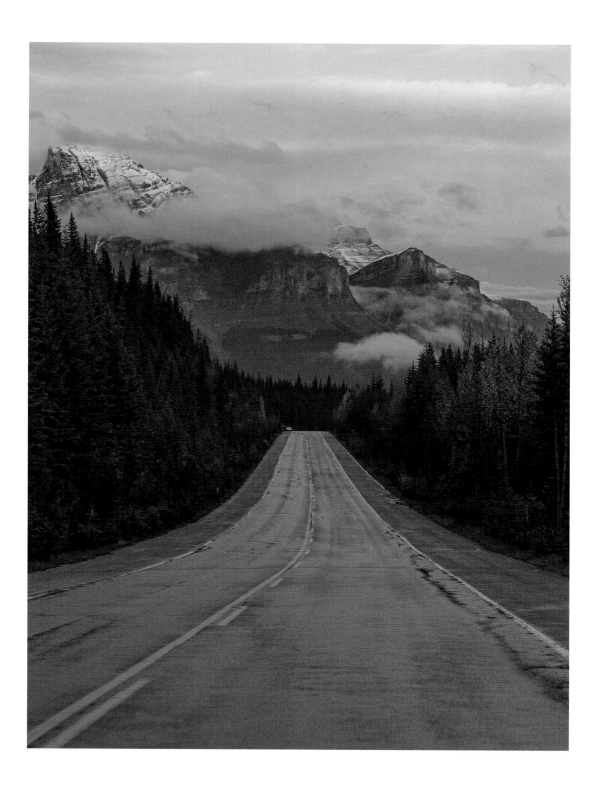

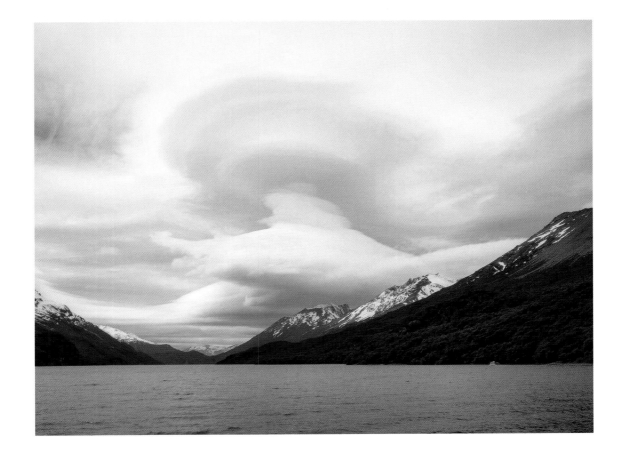

I DECIDED TO approach my aunt and uncle about the money just before Thanksgiving. Totally nervous, but resolute, I kept the paperwork in hand to use in case they tried to deny the facts. I needed the money for Moody Bible Institute, and more than that—I needed to know the truth.

With my uncle out of town on business, it was just me and my aunt speaking. Absolutely terrified, I told her, "So this is what I know . . ." and explained everything that I had learned from my grandmother.

My aunt completely denied it.

Then I pulled out the documents with her signatures showing a million dollars in my name.

She then changed her story saying: "Joe, you don't deserve to be treated like a prince. It's not fair for you to have all this money when we raised you along with your other five brothers and sisters. It's just not fair, you'll never understand."

The hardest realization to come from that conversation wasn't that I didn't get the money. That part was devastating—sometimes still is. Even though my aunt was legally entitled to use the funds for our family, and I benefited as part of the family, I was the one whose mom had been taken away from him. Shouldn't I have had a say in how that money was spent once I grew up? It's tough not to imagine what life could have been had I been able to pursue my running career at Liberty after my freshman year, or pursue my studies at Moody Bible Institute without feeling the hot rush of panic about how I'd pay for each semester.

Far worse than any of that was the recurring worry that my aunt and uncle might have adopted me because they saw an opportunity to get rich quick. That they took me in because they saw an opportunity to get this money, not because they loved me.

After the conversation, I left for camp and didn't return until May. They acted like nothing had ever happened. Giving me hugs and kisses and sending well-wishes for my next big move: starting at Moody Bible. They were telling me how proud they were to see me following the Lord's calling into full-time ministry, and throughout that time, the energy felt off. Something *had* happened, I wanted to shout. Something huge.

I really did believe my calling was to further my education in biblical studies, continue on to seminary, and get a master's degree in divinity. After that, I would become the pastor of a local church and set down deep roots. I had $4,000 to my name, just enough to get me through one semester of school; the rest I'd have to figure out as I went.

Being in a totally new place meant freedom...

But on my way to Spokane, all I could feel was excitement. Being in a totally new place meant freedom, it was giving me the separation from Florida I so needed; I felt this spirit of adventure, like the rest of my life was hovering right before me, and all I had to do was reach out.

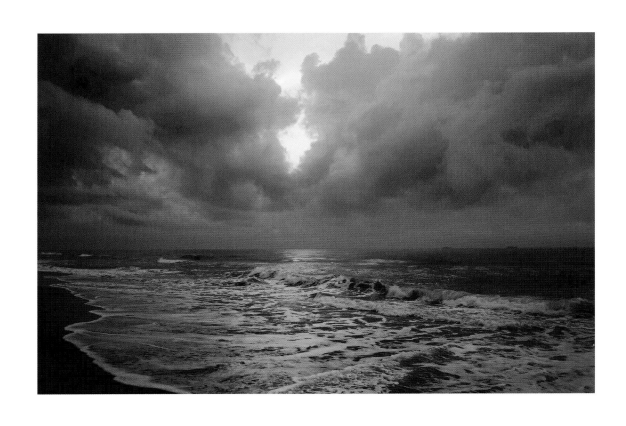

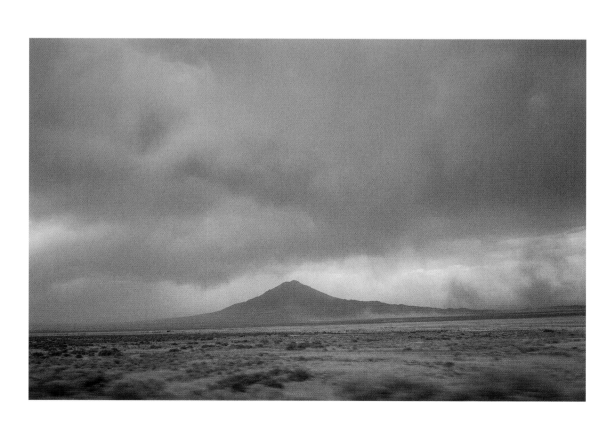

chapter 5

moody x instagram

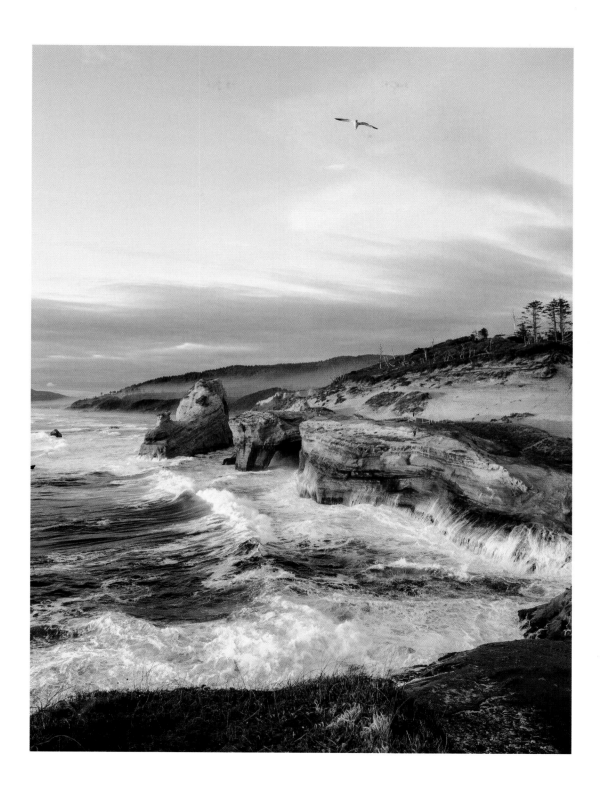

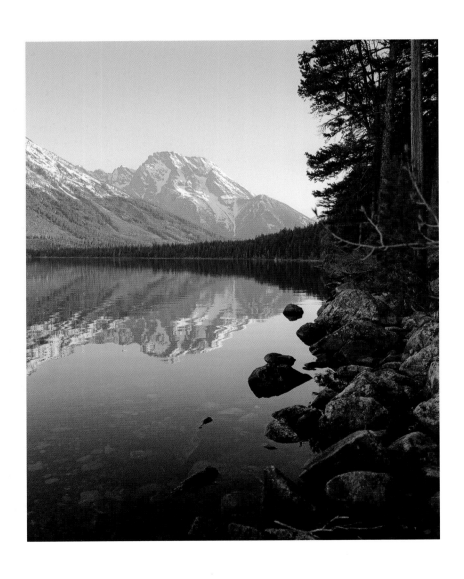

I HAD NEVER really seen mountains before.

I'd flown out to Seattle in mid-August of 2010 with my childhood best friend, Jimmy Meeks, so we could start our journey at Moody, and Jimmy had bought this tiny, beat-up Metro from a relative there for a dollar (yes, *one dollar*!) so we could drive the five hours inland. The Cascade Mountains loomed before us, and the air smelled so clean and sharp—like evergreen and possibility.

The excitement was tenfold compared to what it felt like being dropped off at Liberty a few years prior. Part of that was just from seeing the natural world in a new way, sprawled out before me, and part of that was from feeling so ready to move on from the hardship with my adoptive parents. The conversation I'd had with them about the inheritance seemed to unlock a new tier of curiosity within me, and an uncertain hopefulness about what my life could become, what I could make of it.

As Jimmy and I drove east toward Spokane, I had this feeling that God had ordained the sunset over our shoulders. I was in the passenger seat, all the windows were down, and a summer breeze filled the car as I looked in the rearview mirror toward this breathtaking array of sunset hues streaking the sky. I remember being so happy, and so aware of that happiness, like it was physically filling my entire body. I felt near to God, and hopeful that the season I was heading into would be a transformative one.

Looking back, I can appreciate just how uncertain that time was, in almost every sense. I'd started this new life on the other side of the country with only enough money for one semester, and no clue beyond that how I'd pay for school. No clue when I'd return to Florida, or if I would. No clue what I'd be coming home to, if I did go back.

I figured the best thing to do would be to fully immerse myself in *everything*: school, work, new friendships. The bigger my personality, the stronger I felt it would make my case that I had it all together. That I was fine. So, just like at Liberty, my hyperextroverted behavior in social settings was a mask to keep people from seeing the weight of my trauma. I leaned so hard into that pretending, I could almost believe it myself. And it did help . . . for a time.

Still, I couldn't keep up the facade. I'd gone to Spokane to study the scriptures and the way of Jesus, and in doing so, learned more about how He cared for others, especially the outsiders and the unlikely. Thinking about His life led me to think about grace and forgiveness, two of the things I most needed to grapple with. I kept thinking, *Do I continue to have a relationship with my aunt and uncle? Do I just simply forgive them? Do I try and take some legal action? Do I do neither and just forget about them completely and try to erase them from my memory?*

I was trying to find my spiritual formation, but I didn't know where to find the answers I needed. I was still struggling with the private memories of my life back home. The more I learned, the more difficult it became to accept

I was trying to find my spiritual formation, but I didn't know where to find the answers I needed.

that my adoptive parents didn't heed the message they taught us: to live and lead a life as Jesus did.

Something the scriptures warn about is how the love of money is the root of all evil.

And that was what ultimately led me to realize that the only way forward was just that: by moving forward. I knew that if I wasn't careful I could let the fuel of money—even though it was rightfully mine—cause a cloud of confusion and greed that would follow me forever.

...a cloud of confusion and greed that would follow me forever.

I was afraid that pursuing action against my aunt and uncle would make me like them, and that taking them to court would cause some further division among my immediate and extended family. If I lived like that, I'd be living for the money, and there wouldn't even be a guarantee I would get it. I had to loosen my grip and move forward with open hands instead of fists. I had to let go.

Even though I'd forgiven my aunt and uncle, I wasn't ready to return to Florida. I had it in my mind that if I fell short, if I slipped at all and wasn't able to provide for myself, I'd have no choice but to live there again. I was working like crazy to pay rent and tuition bills—basically, whatever I needed to do to stay in Washington. There was even

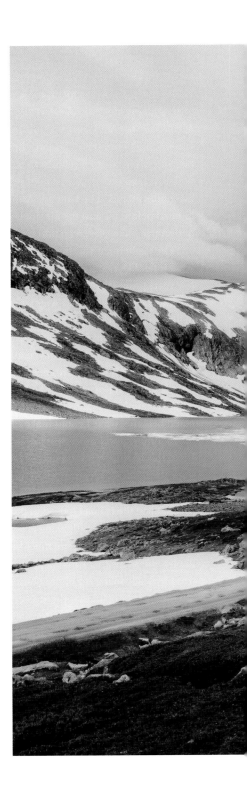

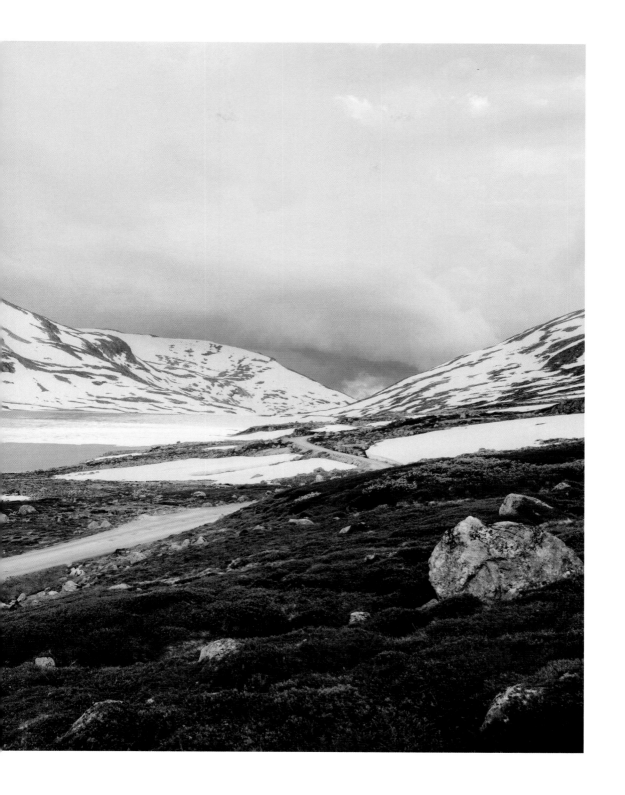

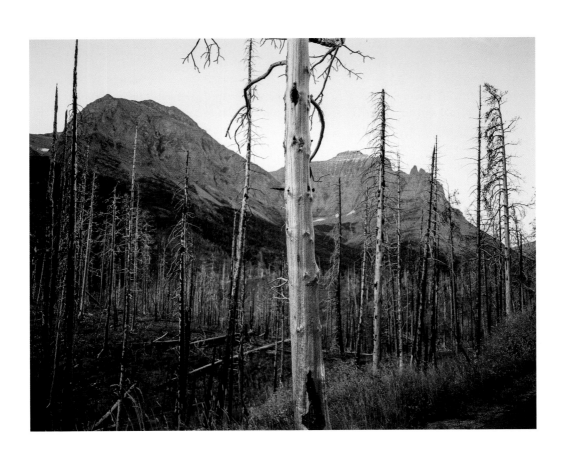

one month where four of my jobs intersected, but it was what I had to do to be independent. And honestly, it wasn't unlike my childhood, when I'd built fences and painted barns or cut grass in order to earn my allowance. I promised myself I would work as hard as I needed to in order to build the life I wanted.

And I did. I worked and worked and made sure that returning to Florida was never a necessity. I didn't stay in any one job for more than eight to ten months; I wanted more experiences, as many as I could possibly have. I wanted to see more, do more, *be more.*

In November of 2011, a little over a year after arriving in Spokane, I did another new thing: I discovered this app called Instagram. At the time, there wasn't an easy or seamless way to share photos to Facebook, but I kept seeing people post to Facebook "via Instagram."

The catch? I had an Android phone at the time. I went to the mall and bought an iPhone 4, downloaded the Instagram app, and so it began. At first, I was just taking pictures of my coffee drinks, silly pictures of friends—nothing serious. But day after day, month after month, I was starting to see things differently. I started to take more time noticing the way the light was hitting my latte, or the angle I was choosing to capture a nature shot. On my walks to class I would take the longer route so that I could see more autumn leaves fall and whistle across the pavement in front of me. Soon enough I was chasing any excuse to be outside and start snapping away.

Aside from running, I had never really had a hobby, and I had no idea what I was doing. Knew nothing about composition. Couldn't tell you what *aperture* meant. *Shutter speed?* Who cares, I just press this button on my phone and can take a picture. That was my world (I know, the early days of being a self-taught photographer are not sexy).

I started to get some of my college friends into it, and whenever we were not working, writing papers, or studying Greek, we were chasing sunrises and sunsets—basically taking any excuse to capture more images. I was just seeing the world in a new way, and I finally got what the hype was all about. I had caught the bug. I was totally hooked.

In the summer of 2013, Moody helped me find a summer job . . . in Maui. Ask a twenty-something with serious wanderlust whether he wants to spend ten weeks in Hawaii? It was an easy yes. I packed a suitcase, and off I went.

That natural beauty was staggering. A totally different kind of beautiful than Spokane. Maui was just so *lush,* and the landscapes were raw and beautiful. Every single night had the most beautiful sunset I had ever seen, each one better than the last. And I noticed that I was getting more and more followers on Instagram, people I'd never met before. They were so excited about my photography, and it was making me even *more* excited about the new hobby.

By the time I went back to Moody to finish out my senior year, I expected to feel settled, even more prepared to step into my purpose. Only I was more confused about my future than ever before. Photography had changed everything.

chapter 6

instagram

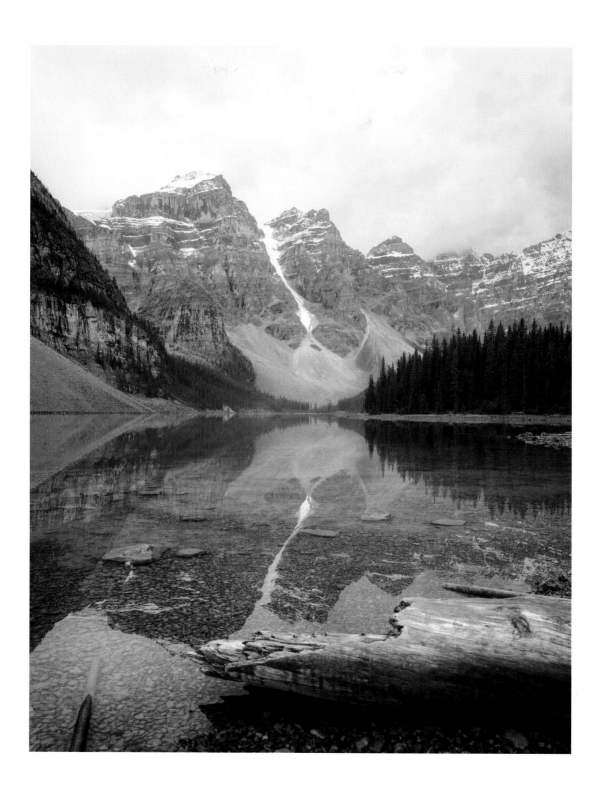

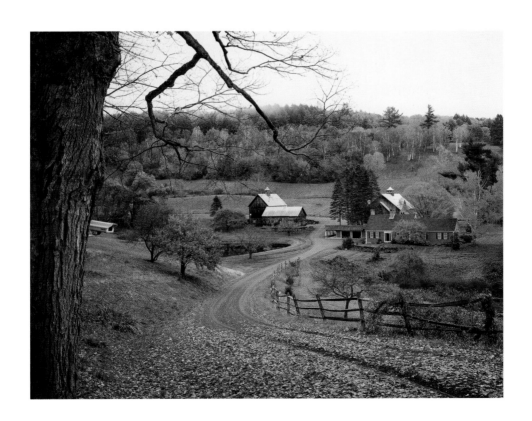

RETURNING TO SPOKANE to finish out my last year at Moody was more challenging than I expected. My time in Maui had caused a massive paradigm shift in my soul. I came back with a passion for photography that burned brighter than anything else. I was confused as to what the next steps were going to be after school, and whether I needed to totally rethink my plans.

That seemed to be the case: I had just fallen completely in love with photography. At that point it was no longer my hobby. I was willing to do whatever it took to learn and grow, and to invest any money that I had—which wasn't a lot—into cultivating this craft. There was still so much about photography that I did not know, but I had never enjoyed doing something more in my entire life—not

There was still so much about photography that I did not know...

even running. I kept envisioning ways to make photography into a career, and couldn't help but daydream all the time about it: I even remember sitting in one of my preaching classes zoned out in the back of the classroom getting lost in the rich memories of Maui, and then snapping back to reality. Thinking, *This isn't it*.

Over the course of that fall and going into winter of 2013, I was still wrapped up in school, but I continued to take every opportunity to explore the Pacific Northwest, meeting incredible people along the way.

Many of them were other photographers who had caught that Instagram bug—we were all amateurs behind the lens, with a shared passion for creating.

One of the people I met was Gregory Woodman, a photographer who lived in Seattle. We quickly became close friends, to the point that he even offered to host me for Christmas. As my plan was to kick it alone again in Spokane, I was thrilled; it would be great to spend the holidays with a family and to explore Seattle. That city had a community of early Instagram users, and many of them were inspirations for me as I started shooting landscapes.

The day after Christmas, when we were out with friends hiking Snoqualmie Falls, I got a notification: Instagram had made me a suggested user. That meant my account was one of the first accounts people saw when they joined the app, with the recommendation that they follow me.

Within two weeks, I gained 55,000 new followers.

I didn't know what to do. I was thrilled that my landscape photography had found some fans, but I felt a newfound pressure. Having that many eyeballs on my photography all of a sudden made me nervous to put work out. I wanted my followers to be interested in what I was putting out, and I didn't want to lose them.

It was an incredibly exciting few weeks, and I wondered if *maybe*—just maybe—God was trying to show me something by making me a suggested user. I know that probably seems ridiculous and sounds hilarious, but it's the truth.

Much as I loved the church, and held on to a dream of becoming a pastor, I was conflicted.

If photography were another way to understand and appreciate the beauty of the world, maybe there was a future for me in it. Seeing people come to my Instagram was the moment that pushed me over the edge, gave me that bit of confidence that maybe there was a way forward with photography. Just maybe I could make it work.

As I entered my last semester of college that spring, it felt increasingly clear that my next step after graduation had to do with photography. Since the iPhone had changed my path, I found a sales associate job at Apple and began working there as I finished up at Moody.

All the while, I was exploring the Pacific Northwest and making photos.

And okay, if I'm being honest? There's a lot of work from that period that just makes me cringe.

To be fair, I put a lot of pressure on myself; at the time, I was chasing Instagram likes and followers. It felt like a numbers game, believing the lie that the more people who followed me, the better my photography was. And so putting out work became more about what I thought other people would like, rather than what *I* liked.

I was chasing Instagram likes and followers.

I don't think that's an unusual feeling. Putting out content you think other people want means that the early work is oftentimes not great—not by your later standards, anyway. And I purposefully left all of the

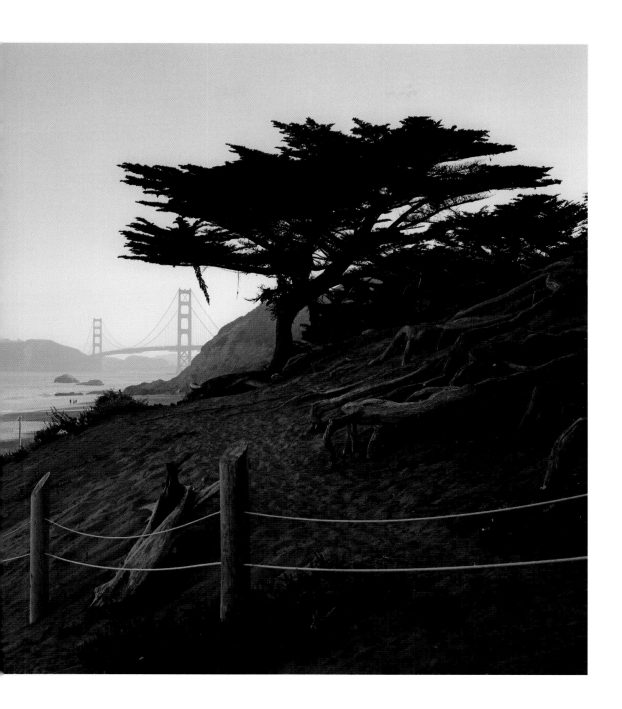

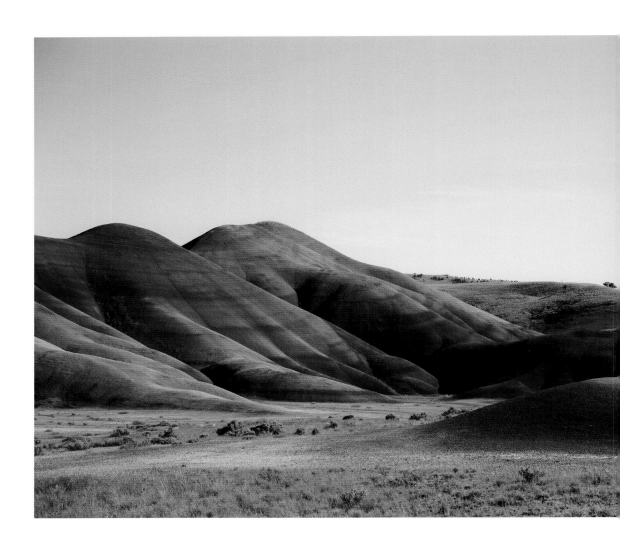

photos on the grid so I could go back every now and then, and check my progress. That work—even if I largely don't like it now—is a reminder of how my career really started.

That work—even if I largely don't like it now—is a reminder of how my career really started.

It took me a long time to move past the question of what other people wanted to see, and to push myself away from thinking about numbers. I think that's fairly common with self-taught photographers; you want to know that people see and respond to your work, and that response is what drives you forward. If I hadn't become a suggested user on Instagram, I don't know if I would have jumped full-on into the pursuit of photography.

Sometimes I still scroll back to those early photos. And even if the composition isn't great, or the saturation feels off, or the filter choices are just totally wrong, I'm glad I have those images. During that time and season of my life, it *was* all about numbers. And then . . .

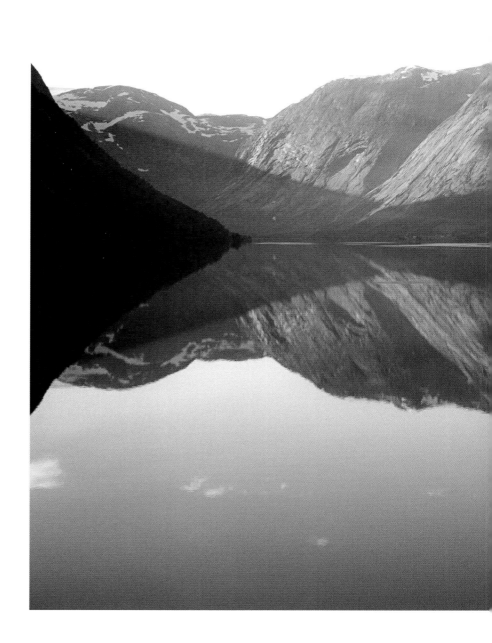

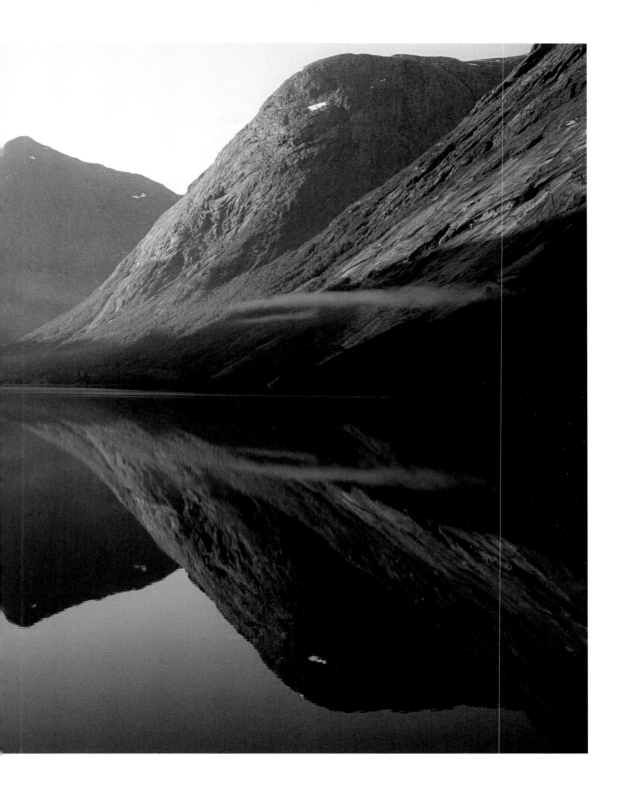

chapter 7

25, 2014

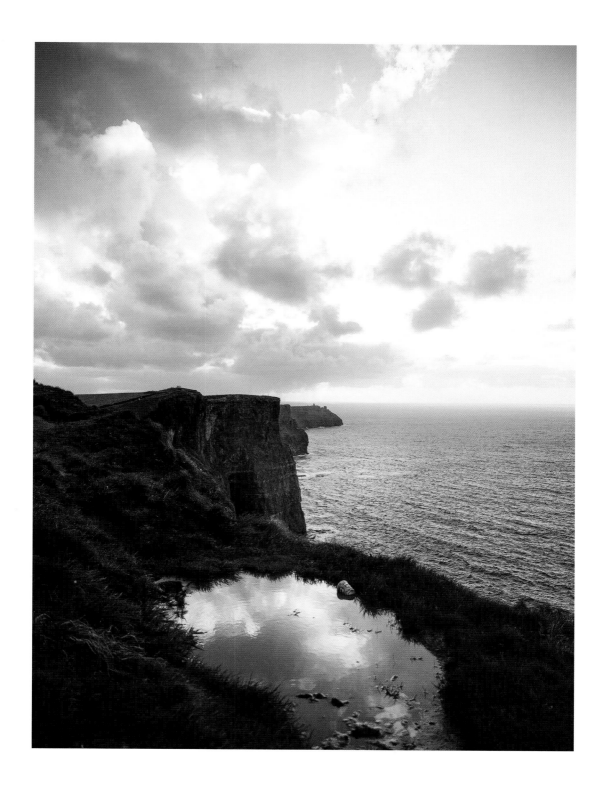

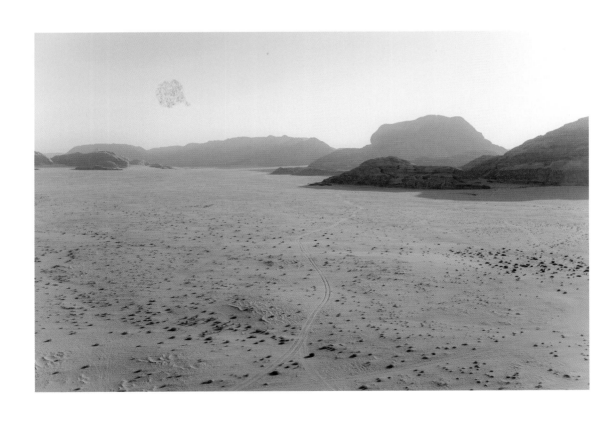

JUST A FEW weeks before my twenty-fifth birthday, my nana called.

Since reconnecting when I was nineteen and at Liberty University, we had maintained a relationship, and would chat at least once a month. I looked forward to those phone dates and how easily we could just catch up and talk.

At one point during the birthday call she said, "I can't believe that if your parents didn't take all the money that you would be getting the rest when you turn twenty-five."

Just like that—totally casual. She sounded reflective, and definitely didn't seem to think I'd be surprised, which of course I was.

I asked, "Wait, what exactly do you mean the rest of the money? I thought all I was supposed to get was the portion when I turned eighteen?"

"Oh, no," she said. "The way we worked it out in the court settlement was that we had won you three million. One million you were to receive when you turned eighteen, and the other two million when you turned twenty-five."

I felt my heart sink. The old anxieties came flooding back.

She claimed that they had decided to portion it out that way because an eighteen-year-old with three million dollars might go totally wild, and it made more sense to the court to separate it into two payments.

I felt my heart sink. The old anxieties came flooding back. The last few years of

progress felt blighted by the resurgence of those feelings, and I began doubting myself. Two million dollars?

She definitely didn't tell me about the second payment years prior when she called me at Liberty. I definitely didn't read that in the box of paperwork I found.

But maybe I hadn't read it correctly? Maybe my grandma was remembering it wrong?

Maybe she wasn't. There was so much I'd been kept in the dark about, after all.

Maybe the money was all gone . . . but maybe it wasn't.

Just like the old anxieties, hope came flooding back during that ten-minute call. If there *was* money, there were so many potential opportunities. I started daydreaming about receiving a check when I turned twenty-five, and what I'd do with it. I could move to Hawaii! I could finally buy a real camera! I could give money to my siblings!

My mind was dominated by these questions for the next weeks. I had worked so hard to close this chapter of my life and move on, but the money had found its way back into the forefront of my life.

Through the paperwork, I ended up finding the name of the lawyer who had been involved in my mother's case, and then found him on Google. I even called him with the hope of getting any kind of information to back up or refute what my nana was talking about. When we finally connected, he remembered me and the case but had since retired and essentially was a dead end. There wasn't much that he could do.

After hanging up, I sat there for a while. There wasn't anything else to do, no other leads to pursue. My aunt and I had finally

come to some kind of unspoken let's-not-talk-about-it-again truce, a tentative reopening of our relationship, but I couldn't call her to ask more questions. The whole thing felt fragile enough without digging into the past.

After that first bout of panic and daydreaming, I felt an overwhelming sense of peace rush over me. Peace from God that everything was going to be okay. That I have no reason not to trust Him. I decided that I'd go about my life and that if I were to get a check in the mail on February 17, great! If not, I'd move on.

My birthday rolled around and there was no check, no call, no email. Nothing.

That was my answer. I had to close that chapter of my life.

And I really tried. There was enough to focus on: Graduation was coming, and I had no idea what I'd be doing afterward. Those thoughts about the possibility of more money were still in the back of my mind, but they came and went. I'd been disappointed once before, and I needed to move on. (Only much later did I find that my grandma had been mistaken about the extra two million dollars after all.)

But despite all of the anxiety, I still felt some peace.

I didn't know what I was going to be doing after graduation, aside from continuing to work at Apple. I had no idea what the next steps were in this new direction and calling of my life. No idea how photography would fit in.

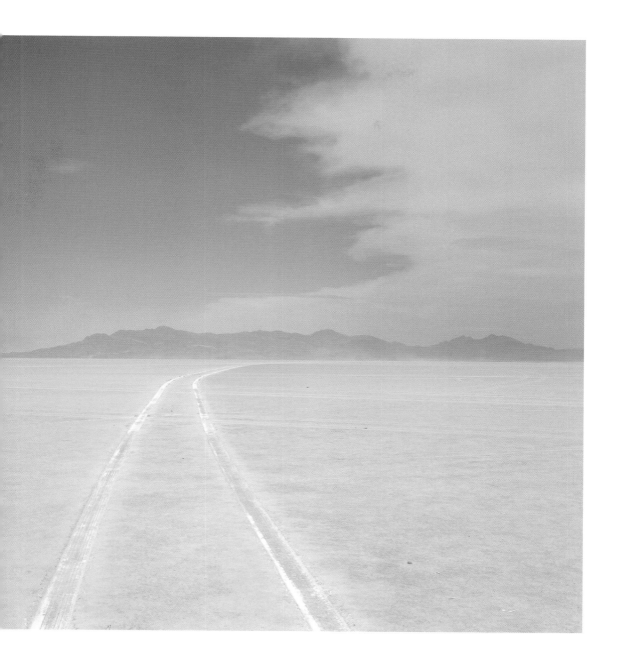

But despite all of the anxiety, I still felt some peace. A lot of anxiety, for sure, but peace about what my future could look like. I figured that, with time, the path would reveal itself; all I had to do was keep putting myself in places with opportunities to grow and learn. In time, something would happen. I had to trust that.

None of my family made it to graduation. I was disappointed, but I understood; we weren't a family who took many trips together, and when we did, we never took planes. We drove everywhere, and going all the way to Washington for my graduation would have been a massive undertaking for them. And on top of that, the family dynamic had fractured. My aunt and uncle had separated, and my aunt had moved to east Tennessee, where my siblings Nick and Rachel were living.

However, just days before I graduated, I received a letter from my aunt.

In the letter she apologized for how they weren't able to be there for my graduation and she went on to tell me how proud my mother would be of all of my accomplishments.

Reading the pages, I just broke down. Even if I hadn't admitted it to myself, I had been disappointed not to see anyone for graduation, and it felt so freeing that my aunt said she was proud of me and apologized for not making it to Washington.

Not just that, but she apologized for how she hurt me and for everything that happened. Now, she didn't exactly say what she meant, but I knew. She didn't need to say it.

To see that apology was jarring, and healing at the same time. I'd spent so many years trying to understand why they did what they did, and trying to get to a place of forgiveness with them. Still, I had to wonder why the apology was coming now, why it had taken four years after me leaving Florida to get there.

I came to the conclusion that during her and my uncle's separation, after which she moved up to Tennessee, she finally for the first time in about thirty years had time to

I believe God started to work in her soul toward reconciling things with me.

think and live on her own. She didn't have the domineering pressure of my uncle over her anymore. I also believe that time away from him allowed her relationship with Jesus to truly blossom. In that, I believe God started to work in her soul toward reconciling things with me. I am not sure if that's exactly the flow of things, but only my assumption in trying to connect the dots. I didn't realize it at the time, but both of us had spent those years strengthening our spiritual relationships, and it had brought us to a place where we could heal, we could move forward.

At the end of the day, she wrote me this letter. Not my uncle. As I saw it, she apologized for her role in the money, whereas he wouldn't, and still has not. However, I am forever grateful that she sent me the letter. Without it, I couldn't have had the confidence to step into the next new chapter: post-college life.

chapter 8

colorado

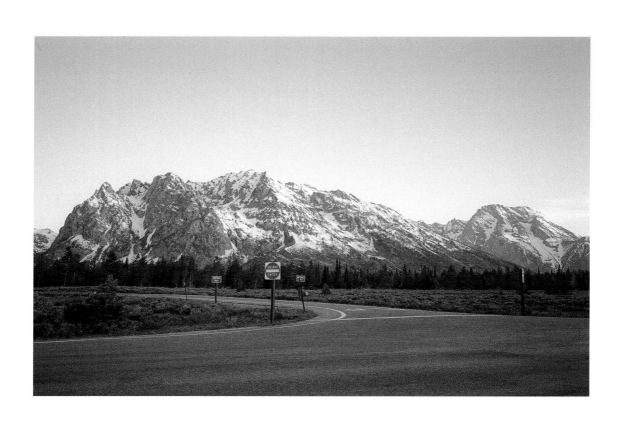

THAT SUMMER, I was working; and whenever I wasn't, I was making pictures.

Without the need to spend so many hours in class or studying, there was a newfound freedom. And as usual, I felt the itch to do *more*. I was meeting people and visiting new cities, including Portland and Seattle. I had the dream of moving to one of those cities, and getting to meet even more creative people from the Instagram community. And even though I hadn't been on the Instagram suggested user list for months, my profile was still growing. I surpassed the 100,000 followers mark that summer and I was just blown away. The surge of new followers showed me that whatever I was doing photography-wise was working, so I just kept exploring, kept making photographs, kept sharing them.

Instagram back in those days was like the wild, wild West.

Instagram back in those days was like the wild, wild West. There wasn't much known about the platform yet, and those of us who'd hopped on the train early were starting to see exciting results. My presence on the platform kept growing, and I was inspired by that movement; it felt like I was finally doing something where my passion could shine through.

At the tail end of that summer I heard from a friend. He was another photographer I'd met through the app, originally from Portland but by then living in Colorado Springs. He worked as a photo curator for the up-and-coming photo-editing app Visual Supply Company—better known as VSCO. That was the app that I had used to edit my photographs on my phone since day one. I loved everything VSCO was making and how it helped me better understand the technical side of postproduction, like how to edit using the HSL scale and how to adjust shadows.

When we were chatting, he mentioned that VSCO was hiring for curator positions and he encouraged me to apply. I was feeling super hopeful, but I remained realistic. I had just graduated from Bible college, I had a degree in preaching, and I was a self-taught photographer on an iPhone. At that point in my life, I didn't even own a real camera.

I was pretty sure I wasn't going to get the job. Like I'd been doing the past year, I just tried to keep my hopes low so that I wouldn't be disappointed if something didn't come through.

But then, just a few days after my Skype interview, I was offered a full-time job as a curator for VSCO's online photo gallery.

I was shocked, excited, I cried with excitement. I couldn't believe it. After so many years of working in retail and chain restaurants like Sonic and Chipotle, and a year of feeling totally uncertain of my path, I would get to go and be a part of a company focused on mobile photography?

It was one of the biggest blessings of my life. But it also meant that I had to say goodbye to the beautiful life and family I had built in Spokane over the last four years. These four years were some of the most special, challenging, rewarding, and growing years of my life. I was incredibly sad, but wildly excited for

this new chapter and a step closer to following this new passion of making photography my full-time job.

One of my best friends, Cory, offered to help me move to Colorado: one last photo trip along the way to Colorado Springs.

Just days before leaving, my pastor gave me a little Honda Civic so that I would have a car. In a season of my life when things had been so difficult, I didn't hope for very much— and that act of kindness just blew me away. It's something I think about to this day, how casually he was able to give me such a generous and incredible gift.

Imagine if we held our possessions, the things we buy and love so much, if we held those things with open hands, freely. Ready to be a blessing to another. That act—even though it may have been small to him—had a massive impact and stuck with me all these years. It was an omen, I felt, for the next season of my life.

It was a precious road trip that I'll remember forever.

Cory and I had an amazing trip and made plenty of photos during our drive to my new home in Colorado. We spent hours chatting about the last four years falling in love with photography together and all the lengths we went to to make the photograph. It was a precious road trip that I'll remember forever. I moved into my apartment on the last Friday in August and started work at VSCO on the following Monday.

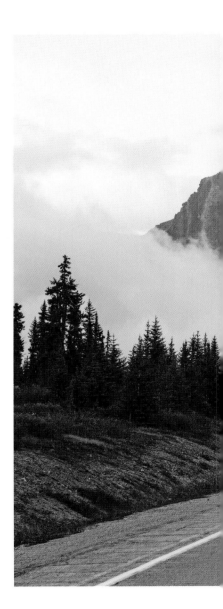

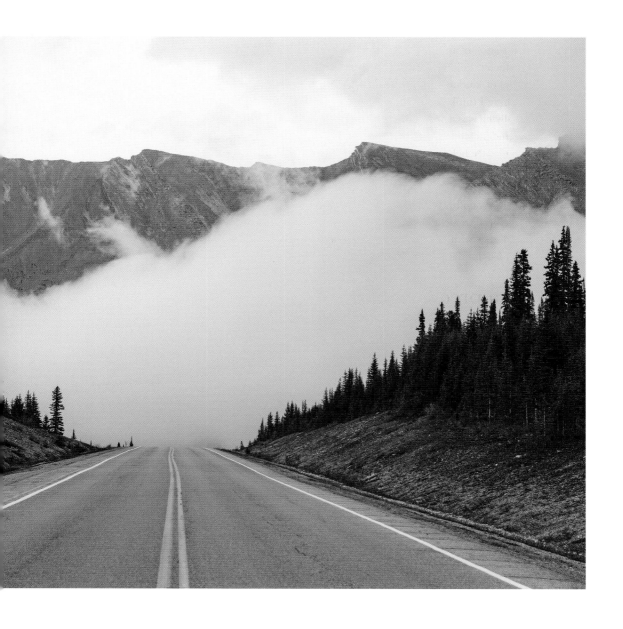

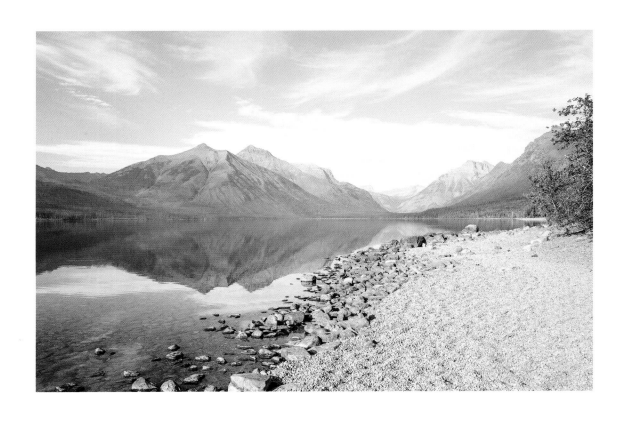

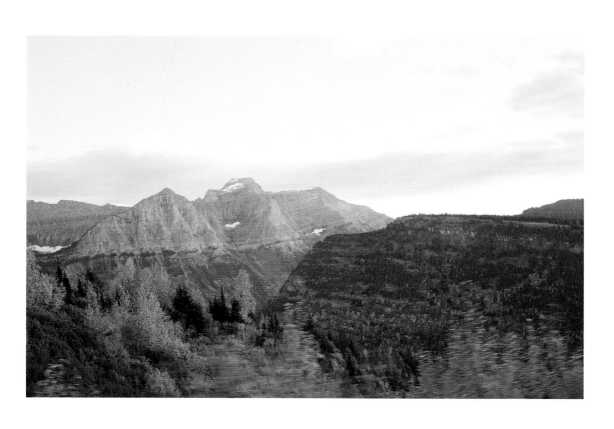

chapter 9

madison x portland

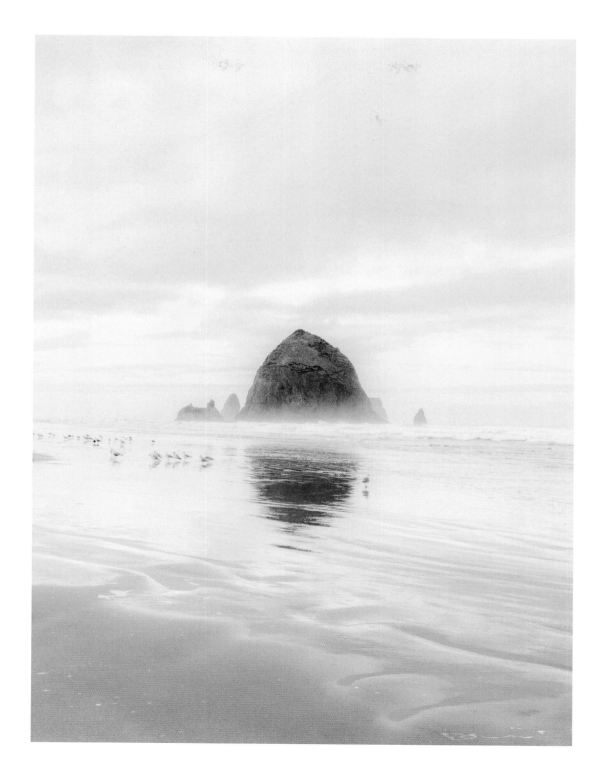

I WASN'T ONLY falling in love with photography, though.

While Cory was driving, I was strategizing. Not for my new job, or really anything that had to do with work—I was trying to figure out the best opening line to talk to a girl.

A few weeks prior, my friend Sara—a photographer from Nashville—had posted a portrait to Instagram of this stunningly beautiful redhead, Madison. Luckily, I knew exactly how to play it cool: Follow her immediately, check. Find her on Facebook, check. Subtle, right?

As I was preparing for my move to Colorado, I was also thinking, *How in the world do I create a conversation out of thin air with this woman? Out of the blue?* There was just no easy way to go about it, and in the best-case scenario that we got along . . . she still lived in Nashville, and I was about to be full-time in Colorado.

Still, while I was on that road trip, she kept crossing my mind. I kept posting to Instagram, and while seeing the landscapes and taking the shots, Madison was on my mind. I wondered if she would find beauty in the same things I

I wondered if she would find beauty in the same things I saw...

saw, and I couldn't help—as I clicked Post—but hope that she might see and be impressed by the photos.

One night, after seeing this epic sunset in the mountains of Wyoming, I was filled with

so much courage I finally sent the DM. Again, *super* smooth. I started with some awful line like "I enjoy your style."

But it worked! It started the conversation. By the end of that first conversation she gave me her number. And in case you were wondering, I have a *massive* grin on my face while writing this.

Those first few weeks of my new job and getting to know Madison were something special. I was getting the lay of the land at VSCO, settling into the Colorado life, and learning more about photography and art every single day. I had an incredible team of supervisors who helped shatter my understanding of what photography was, and until that happened, I didn't even know I'd needed it.

Really, I didn't realize until VSCO how narrow my understanding of photography was. I thought it consisted of epic, trendy landscape photography from the 2012 through 2014 Instagram era. But VSCO quickly helped me see the beauty of the world in a new way.

My supervisors were great; they gave me homework to research some of the photography greats. Sure enough, even though I had never heard of them, I fell in love with their work; they became massive sources of inspiration, some of my favorite men and women to ever pick up a camera. Even to this day.

Those ten months at VSCO became my "photo school." It was during this time that I fell more deeply in love with the craft, which up to that point I didn't think was possible. Working there helped to lift the veil that was over my eyes, and I truly started to see what this photography thing could be about.

VSCO played a huge role in helping me unlock my true potential. It's been labeled as the anti-Instagram app, because it isn't at all about public recognition. There are actually no numbers. You can't see who or how many people follow your work. There are no likes or comments. It is purely about the art. About the community of creators sharing their voices from all over the world.

And that was part of my job. I was sifting through thousands of photographs a day from all over the world. Selecting the best of what was submitted. It was pretty repetitive in practice, but seeing tens of thousands of photographs a week gave me more scope on my own taste, and what worked compositionally.

So much of what makes a photograph good is subjective, anyhow, but I learned more about objective photographic themes that make work resonant. Beautiful light, for example. Emotion. Movement. Compelling composition.

As I began learning these new things, I started to see them show up in my own work. I started to fall in love with portraiture and

There were more things I could photograph, but I hadn't realized that until Colorado.

daily mundane findings. I started to see so much beauty in the quieter parts of human life, and in doing so, realized that I didn't need

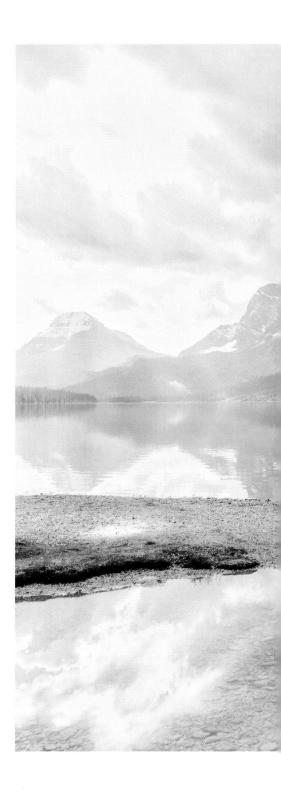

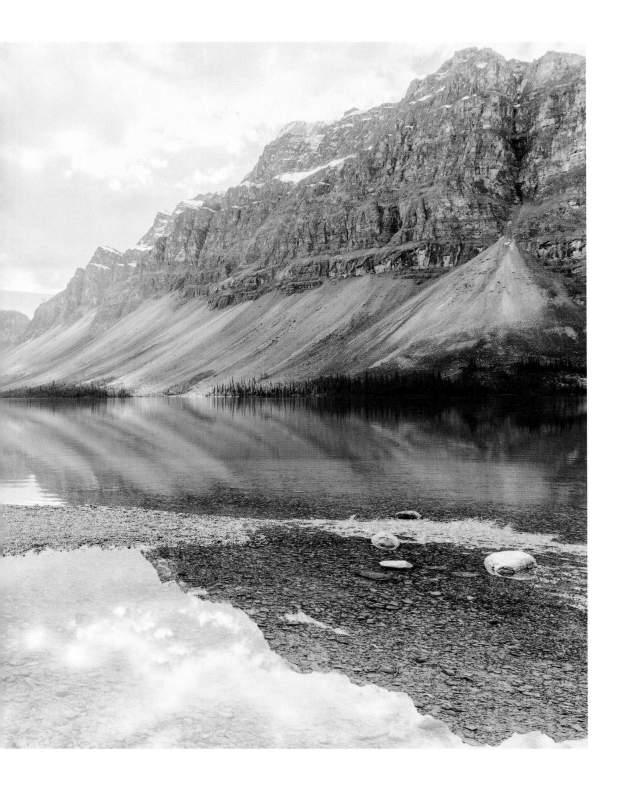

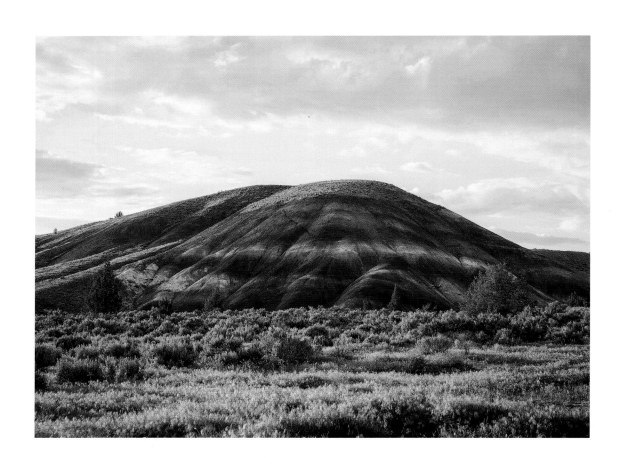

the Pacific Northwest landscapes in order to make a beautiful photograph. This was a precious time in my early photography development, to realize a portrait could be as epic as a mountain scene. There were more things I could photograph, but I hadn't realized that until Colorado.

And then, of course, there was Madison.

With all the special and incredible things happening during that time, Madison and I were talking every single day. First we texted, then we started having phone calls, and soon enough we were writing letters to one another. Eventually we started chatting on FaceTime.

It was so easy to talk to her, and there were more similarities between us than I could have realized. Just in those first few days she mentioned she was born in a small town in Florida, and I got weirdly excited—no chance it was Inglis, but maybe I'd heard of it?

She told me it was Crystal River.

I actually gasped. That was the neighboring town to Inglis; I'd gone to and graduated from Crystal River High School.

I freaked out and told her about that coincidence. She then went to her mother only to find out that her parents had graduated from Crystal River High School. What are the chances?

After talking for about a month, I began to feel that I needed to meet Madison. By that point, we were talking so much I felt like I was in a trance; I'd never felt this way about anyone before, and during a time when I was just delving into a new city and a new job, it was scary to feel like I was falling for someone this fast . . . let alone someone I'd never even met.

All we could do was talk—and that was actually so special. It wasn't like we could go on in-person dates or to the movies; I couldn't hug her. I had no idea what her laugh sounded like in person. I would spend hours in my little apartment in Colorado on FaceTime with this woman in Nashville—totally counterintuitive to how modern dating works, and yet I was falling in love with a woman I had never met.

Neither of us said as much, but neither one of us wanted to start dating before we actually met in person. So, I booked the flight.

Now, I'm a big fan of rom-coms—and I'd been pretty confident in romantic situations before—but that entire flight to Nashville was nerve-racking. Sweaty hands, couldn't think straight. I hadn't been too suave with my opening line on Instagram, so I figured that in finally meeting Madison, I'd get it right.

When I saw Madison in the terminal, I was going to walk right up and kiss her.

Throughout the plane ride, I kept replaying the plan in my mind: When I saw Madison in the terminal, I was going to walk right up and kiss her. Just take my Tom Hanks moment, and go for it. I'd be totally smooth.

Well, that plan went out the window as soon as I saw her. There she was, leaning against a pillar at the end of the terminal, and I realized I wasn't going to be charming like Tom Hanks—man, I wasn't even going to *reach* her. I literally couldn't keep walking.

I was stunned. She was more beautiful in person than I could have ever imagined.

When I realized I'd been standing there for way too long, I finally walked toward Madison and hugged her. Not quite the sweep-her-off-her-feet kiss I'd planned, but I felt like I'd been knocked backward. Here I was, trying to impress her, and with one hug I knew this was the realest love I'd ever experienced.

That weekend with Madison only confirmed I'd met my soulmate. Meeting her family, going on dates around Nashville, all of it was amazing. Before I left for Colorado, I asked Madison to be my girlfriend—distance be damned.

During that time, my Instagram page was growing like wildfire. During those first three months at VSCO, I was gaining what felt like close to a thousand followers a day. By spring of 2015, there were nearly four hundred thousand people following my page.

It was the most demanding period of my young life at that point. VSCO was still such an incredible environment and I was not looking to move on to something else whatsoever. But during a little four-day trip to Portland early in 2015, I met up with an Instagram friend, a fellow photographer and pastor at a church called Westside: A Jesus Church. Ian Nelson was his name. I was familiar with this church as one of my favorite teachers of the Bible, John Mark Comer, was the head pastor of this church.

Meeting up with Ian after being internet friends for years was amazing. We were just doing the typical Portland stuff, sipping on some single-origin coffee from Kenya at Coava Coffee Roasters, when he dropped this incredibly unexpected job offer at me. He said he wanted me to come be the creative director of Westside Church with him and his team. I was shocked. Excited. Confused. Told him I would think, pray, and talk to Madison about it.

After weeks of thinking and discussion, I decided that this was the perfect opportunity for me to combine what I had learned in Bible college with my newfound love of photography. To blend the church and art was the perfect combination for me. As much as I didn't want to leave my new family at VSCO I felt God was pulling me into this next phase of my life.

This was a very tough professional decision—one of my hardest decisions, actually. I loved VSCO, but Westside was in the Pacific Northwest, which I was really missing, and they were able to offer enough money that I would have more freedom. That money would make it easier to travel and see Madison, to get the cameras I wanted—not to mention I'd get to live in Portland.

The team at VSCO totally supported my decision and to this day I am still close with a lot of my colleagues and bosses that I met while I was there. I packed up my life in that little Honda Civic and moved to Portland to begin again.

I packed up my life in that little Honda Civic and moved to Portland to begin again.

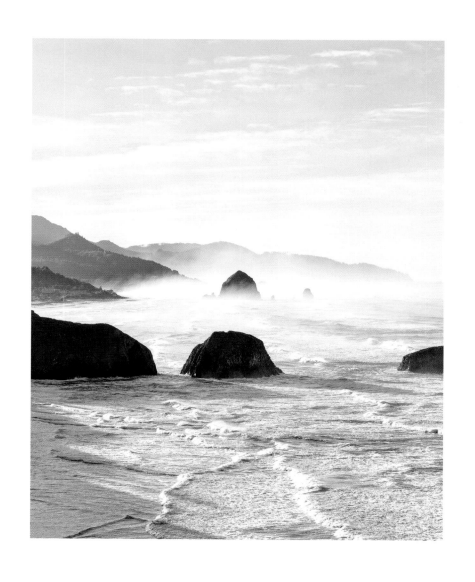

chapter 10

marry me, maddie

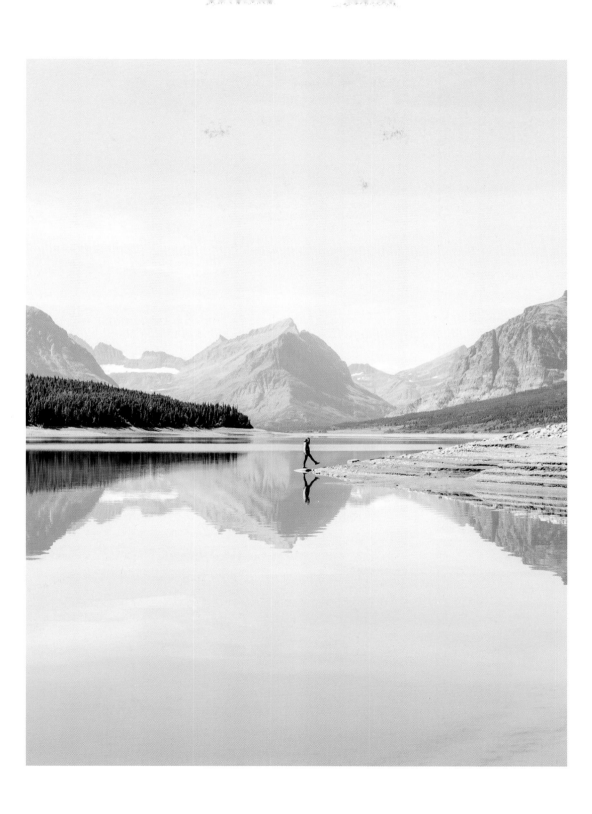

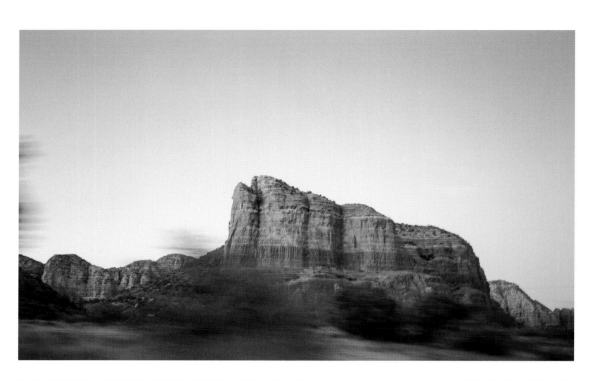

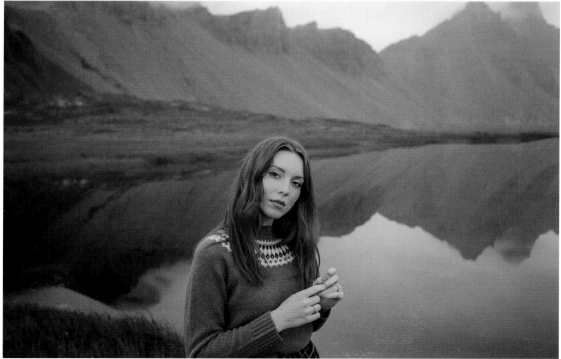

BY MARCH OF 2015 I knew I wanted to marry Madison.

The feelings had been building for months, and I knew—I just knew—she was it. The one. She was my future and I wanted to build a life with her. And I was pretty sure that, even though I'd botched the first-airport-kiss thing, she wanted the same.

Despite the distance, our relationship was blooming. We flew back and forth to visit each other, and during each visit, my love of portraiture continued to grow. I hadn't realized how emotive or how incredible portraits could be until I began making portraits of Madison. This newfound love toward Madison, combined with my growing love for portraiture and the new artistic discoveries VSCO had helped me unlock for portraiture, was immense. Every trip to go see her or her coming to visit me in Colorado was a new opportunity for me to photograph her. To study her and learn how she moves. How light hits her.

As we were falling more in love with each other we both also fell in love with this method of communication. She allowed me to bug her for one more portrait here, oh, and one more over there. Bless her. She became—and remains—my muse.

During one of my visits in March that year I pulled her father, Bill, aside and made my intentions known: I was asking for his daughter's hand in marriage. He lovingly and openly welcomed me into his family, as did Madison's mother, Tena. They were so excited and wanted to help me with surprising her with the proposal. I had saved most of my salary from VSCO so that I could buy her the best ring I could at that stage of my life.

So in April, I decided to take an early flight to Nashville and surprise Madison with a day of adventure. I wanted to re-create our first date from when I had visited eight months before. Of course, when she saw me she was shocked but I'm sure she soon knew exactly what was going on (I'm horrible at hiding secrets). She totally knew.

We went through our very simple first date, re-creating the experience together but knowing each other so much better. It was perfect. In the afternoon we drove to a waterfall about an hour away from Nashville. I had Madison's two closest friends there hiding behind trees, waiting to photograph the moment I asked her. The landscape was beautiful, but more than that—so was Madison.

I honestly cannot remember what I said but all I know is that it ended with her saying yes.

I honestly cannot remember what I said but all I know is that it ended with her saying yes. When we went back to Nashville and celebrated with family and close friends, it was such a celebration. My photography had somehow, miraculously, brought me to the girl of my dreams. I was marrying into an amazing family. I'd get to make portraits of Madison for the rest of my life.

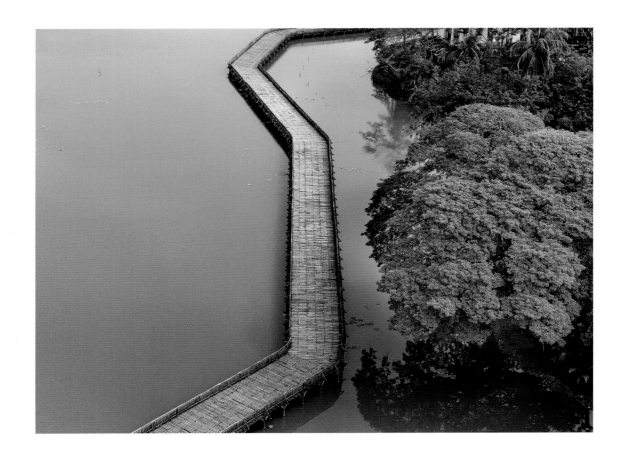

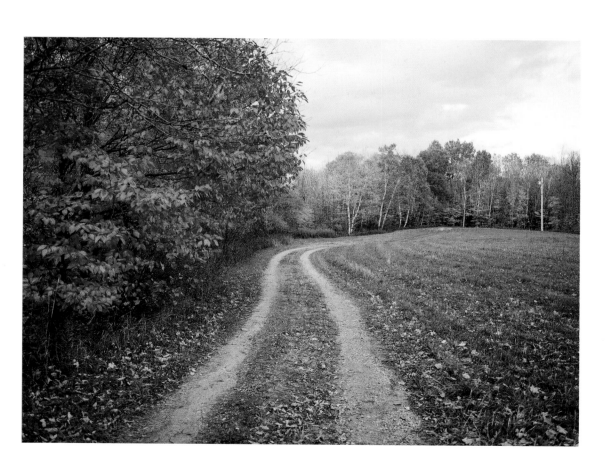

chapter 11

iceland x portland

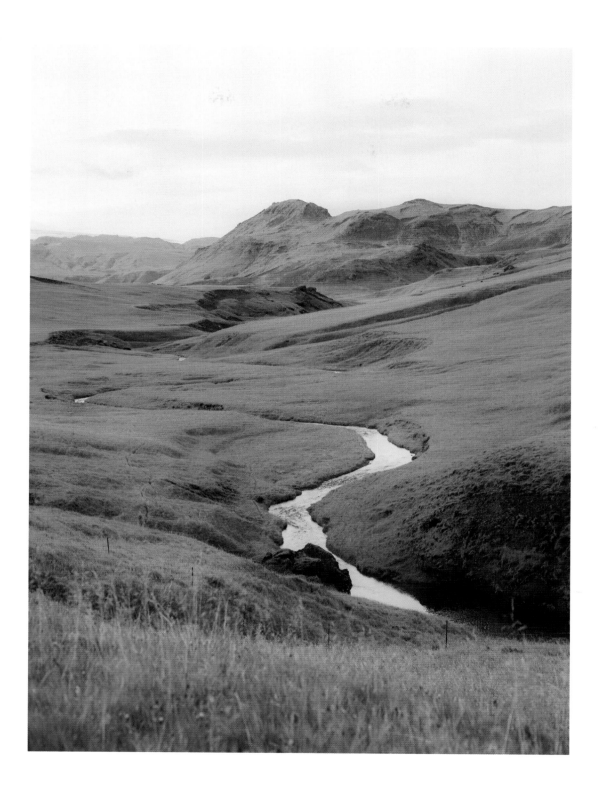

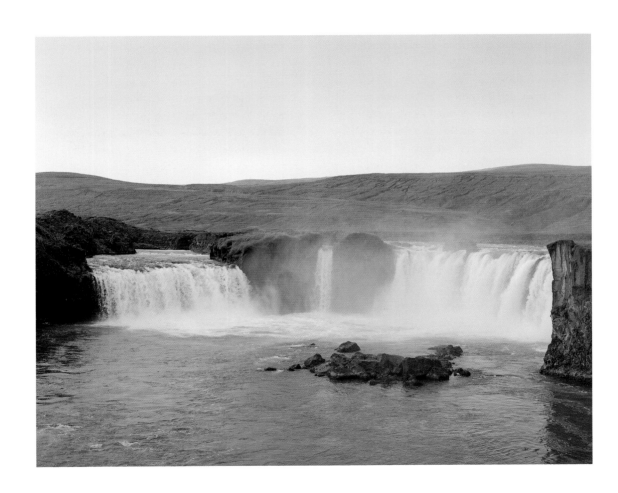

FOR THE MAJORITY of our engagement, we planned to get married in Nashville. It made sense: All of Maddie's family was there, and most of mine were nearby in east Tennessee and Cincinnati. It would be easy enough for everyone to attend, but we started running into issues: In order to get married that fall, we would have to find a venue immediately.

But everything was either booked or so unbelievably expensive we couldn't even consider it. Then one day Tena said, "What if we did a little destination wedding in Iceland?"

I couldn't believe it. Usually, from what I understood, the mother of the bride wants something close to home. But Tena, like Madison and myself, has an adventurous soul. I looked at Madison, Madison looked at me, we both looked at Tena: It was an easy yes.

It seemed serendipitous. Madison and her family had been to Iceland the year before, and they had absolutely fallen in love with the country. Even though I had never been there, I was on this Iceland kick after watching *The Secret Life of Walter Mitty*. That movie just stirred a wild depth of wanderlust for Iceland.

Planning the wedding was fairly easy to do. We needed to get legally married in the States, and then we could hold the ceremony itself in Iceland, in a little black chapel in a gorgeous field. Booking the chapel would be well within the budget, and it meant we'd get to be married in one of the most beautiful places in the world. Seemed like the perfect note to start the biggest adventure of a lifetime.

We decided to invite only family and a few close friends. As with my graduation, unfortunately my family couldn't make it. So I had four of my best mates come: Jimmy was my best man, Ian was our wedding officiator, Cory and Gregory came along as our wedding photographers.

While those were the most nerve-racking two days of my life, I had never been more ready.

We were set to wed forty-eight hours after landing in Iceland. While those were the most nerve-racking two days of my life, I had never been more ready. One of my favorite things about Madison is that she has this deep desire and thirst to live life to its fullest. She has a kindness that I had never experienced before, a quality I didn't even realize I needed in a life partner. She is gracious in love. Wildly creative, she inspires me to this day to wake up and be better. She knows—and she knew then—how to lovingly call me out when I am being difficult to be around or being selfish. She wants what is best for me. She is for me, and not against me.

That day when I sat in the chapel overlooking the field, I realized that I was about to step into my full future. By exchanging vows, Madison would become my home. The ceremony was perfect—emotional and life-giving. The most important thing that happened that day was the fact that our mutual love of faith and God's role in our lives created a beautiful bond. That through all the good, the bad, and the ugly, our love for one another would remain.

Not only was I getting Madison as a life partner, I was also getting her family. I was

gaining two new brothers: Cory and William. And then there were her incredible parents. I believe God knew what He was doing when He brought us into each other's lives. Bill and Tena have been such amazing, warm, loving, and accepting in-laws. And in a way, they became parental role models. Even at twenty-six years old I realized that it wasn't too late to find stability; there I was in my mid-twenties getting a new set of parents. I didn't know just how badly I wanted that family until I had it.

After our honeymoon in Paris we moved Madison out to Portland to truly start our life together. That first year was challenging for both of us. New city, new job, new friends. Everything was new. Everything was different. Especially for Maddie. That was her first time away from family. But looking back now, and as we talk about often that first year was huge for her in becoming the incredibly strong, creative, bold, and independent woman she is now. We both made strides together in our creative life. She stepped into this new role of fashion blogging as her work on Instagram started to also grow. I kept getting freelance photography opportunities during the time I was still working at the church. Thankfully my good friend and boss Ian was cool with me taking most of these side photography jobs.

After Iceland, returning to the Pacific Northwest with my bride was so inspiring. I remembered how much I loved photographing landscapes and trying to find new ways of seeing land and photographing it. And on top of that, I loved making portraits of my wife in the beautiful PNW locales—against the firs, along snowy roads, and among the landscapes. Along with doing so, I began to take more

street photographs and get more invested in capturing mundane human interactions. I found out I loved taking these candid shots.

The more I experienced life, the more my understanding of photography evolved. There were more possibilities, and there wasn't one singular lane. Landscape photography was my first love and always will be, but then I fell in love with Maddie, and through her, I began to love making portraits of people.

Landscape photography was my first love and always will be, but then I fell in love with Maddie, and through her, I began to love making portraits of people.

Landscapes got me caught up in the beautiful mess of making photographs for a living, and so it is only right for this book to be filled with some of the most precious landscapes I've encountered over the years. But during our time in Portland I was starting to see everything though a frame.

And when I say everything, I mean *everything.* Light, human interaction, or even the lack of interaction started to catch my eye, over and over again. Not every moment I was able to capture. Sometimes and oftentimes I would just take a second or two longer to

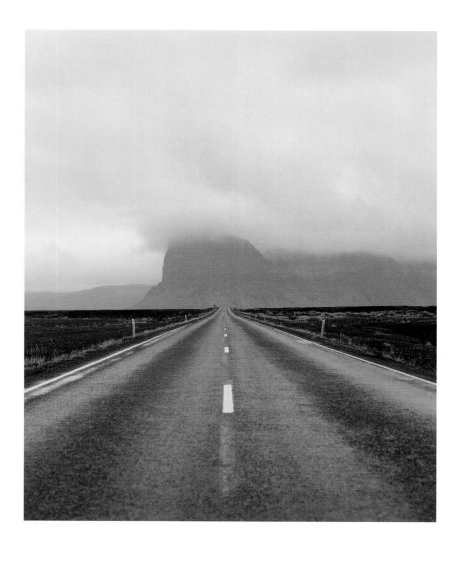

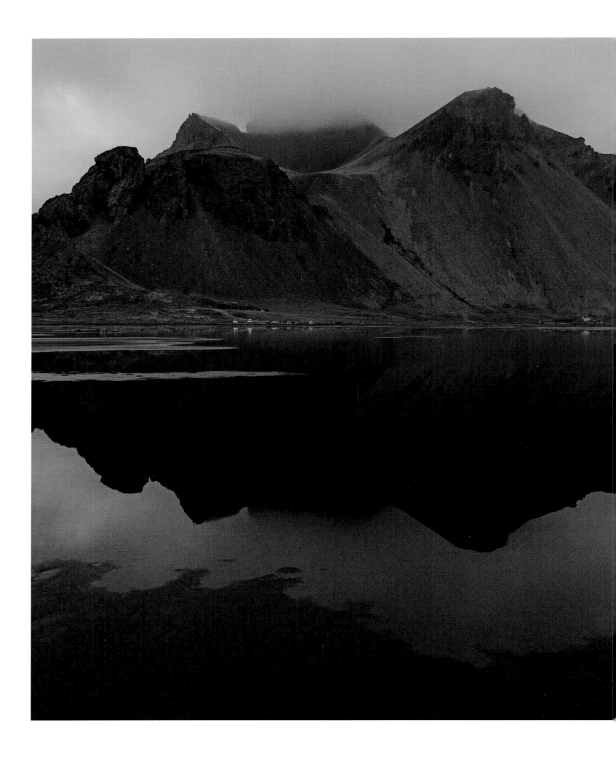

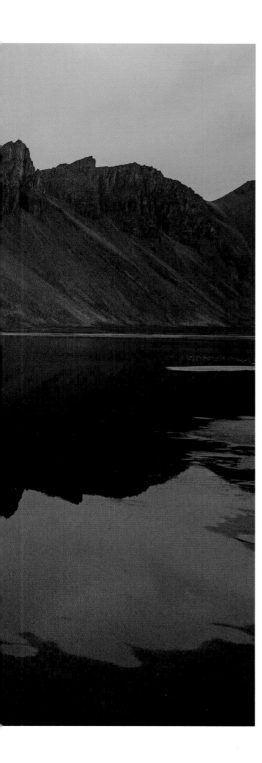

fully observe and use that as an educational moment. I'd ask myself, So why did this scene catch my eye or make me capture it? Was it the light? The composition? Emotion? Or the colors? It made me realize even more why people loved Instagram and VSCO and other photo-sharing apps so much; to some degree, they trained your eye to recognize and love human expression and nature.

It was sort of liberating to no longer be dependent on an epic landscape scene to make a photo anymore. Everything else started to become alive. The simplest moments started to become an opportunity to learn and refine my eye to see life in an honest way.

And I deeply believe that starting to grow my own family was part of what allowed me to experiment with portrait photography in a new way. The love and unconditional support of my wife, the knowledge that we were building something beautiful together, all of that made me feel more inspired to get out there and chase sunrises—only now I had someone to chase them with.

Whether I was on a beach in coastal Oregon waiting for the sun to rise so I could make portraits of Madison, or capturing moments of life on the street, I felt a new hopefulness about the ways in which people could interact and really see one another.

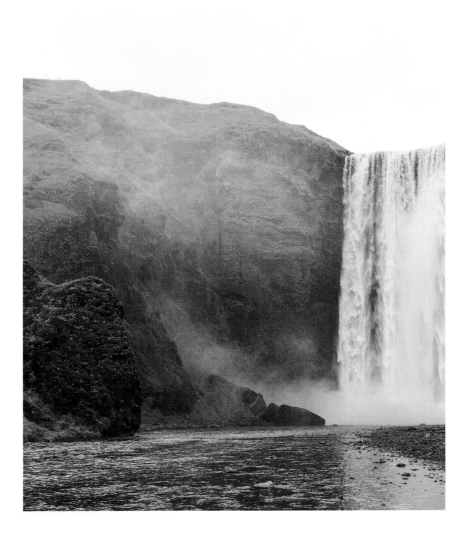

chapter 12

father figure

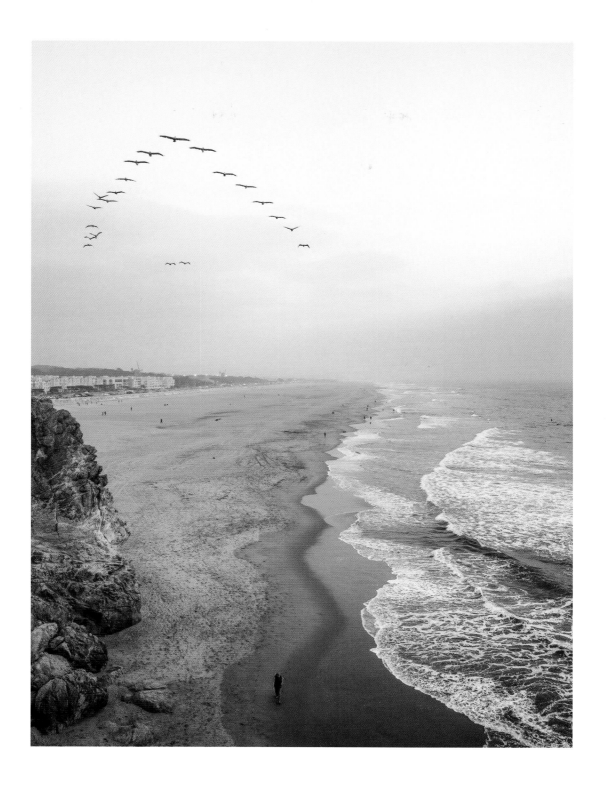

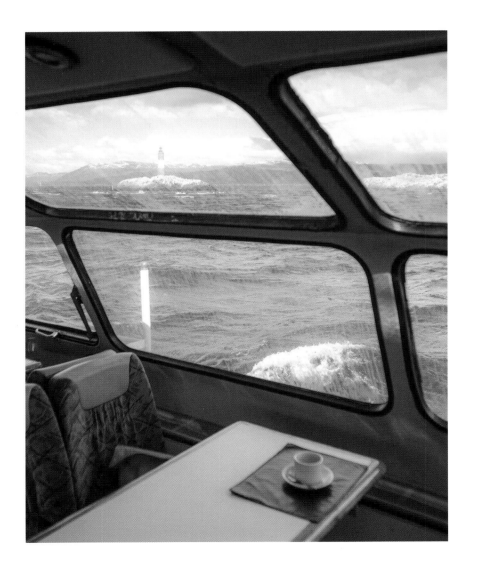

IN MY PORTRAITURE, I realized I gravitated toward family scenes. It gave me another chance to explore the bonds that during my own childhood had been so tenuous and, at times, fractured. Making the photographs of other families offered me healing and left me inspired; it made me hopeful for what Madison and I were on our way to creating.

Of course, I still had fraught feelings about family; I was twenty-seven and I still didn't know my father. I'd tried to find him before, but my mother hadn't shared his identity before her passing, and from what I knew, she had never told any of her siblings who he was either. So while I looked, I was basically grasping for straws; and even as my life progressed, from time to time I wondered whether he knew about me.

Then, in the summer of 2016, my good friend and then-boss, Ian, called me. In his spare time, he was working as a behind-the-scenes photographer for a show called *Relative Race*, in which couples basically journey across the country in pursuit of unknown family members. Ian knew that for years I had been searching for my father, and he thought this would be an opportunity for me to find him.

I didn't know if that would even be possible. The way the show worked was that we didn't know who we were meeting—not even whose side of the family tree!—until we knocked on the door. So while Ian and Madison and I all hoped that it would be my father on the other side, none of us could know for sure.

From the time I was little, I'd been told that just after I was born, my mother mailed my father a letter and a photograph so that he knew he had a son named Joseph. *I* had always

known he existed, but I needed to know—for my own sanity and growth as a man—that he had known I was out there, and didn't seek me out. I promised myself that if I ever met him, I would ask; I would seek that closure.

Approaching his house was one of the strangest, most out-of-body experiences of my life to date. I just had this instinct. Walking up the path, seeing the seventy-seven-year-old man in the doorway was pretty surreal. I didn't recognize him at first. I had the photo of him that my mother took when they were together, but that had been taken thirty years before.

However, Madison knew almost immediately that it was my father. By the nature of the show, it was a competition, and me being a former athlete, I love winning. I was in game mode and completely oblivious to the fact that the man before me was the one I'd been thinking about my entire life.

I was in game mode and completely oblivious to the fact that the man before me was the one I'd been thinking about my entire life.

When we first saw him, he was being escorted down the front steps by this beautiful girl that I did not recognize. Then the gears started to turn; could it be? It couldn't. But was it?

The closer he got, it started to register that I was seconds away from hearing my father address me for the first time. Emotions started to take over and when we first hugged, I began crying.

The girl walking him down the steps turned out to be his daughter, Carisa, whom he and his wife adopted from China when she was a baby. We hit it off immediately, and the group of us went inside for dinner and a lot of long overdue catching up.

I knew that I did have to ask the question eventually, and the moment finally came after a dinner during which he told me stories of his childhood and growing up in Alabama, and his time in the military. My father said yes, he had received the letter. He didn't say much after that.

It was very difficult saying goodbye the next morning. He was in poor health and his throat cancer had just returned for the second time, and I didn't know whether we'd see each other again, or if there was a possibility to build our relationship from there. Before I left, I gave him a big hug, and told him I loved him—and, in vintage dad mode, he said it back and slipped me $200 and a giant atlas for our continued travels on the show.

I said goodbye to him not knowing that those twelve hours would be our first and only time spent together. And yet, those hours unlocked a door to my family that I had thought for years was forever closed.

Meeting him led me to meet more siblings: my sisters.

Meeting him inspired me to think more critically about how I wanted to be as a father.

Meeting him reminded me that the past isn't always doomed to repeat itself.

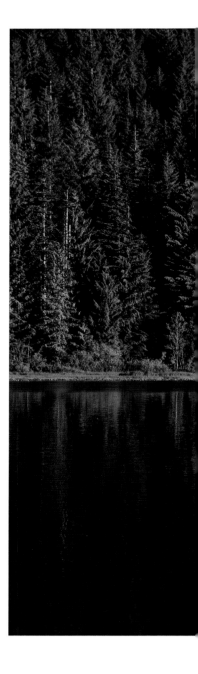

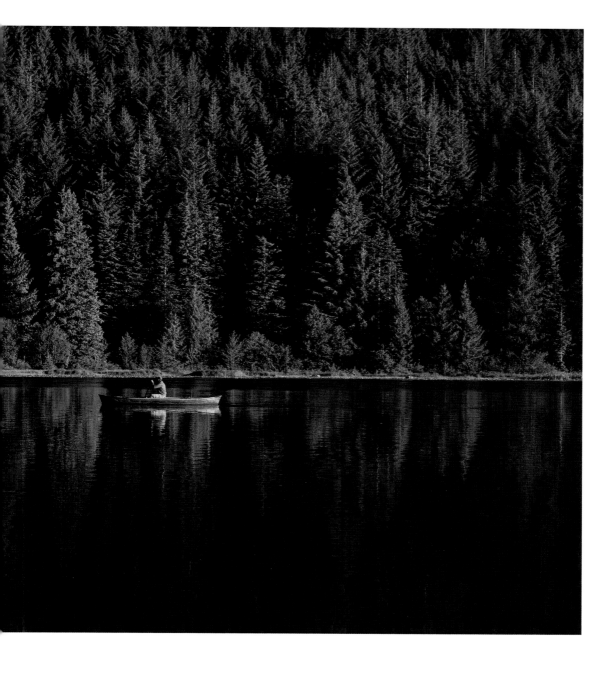

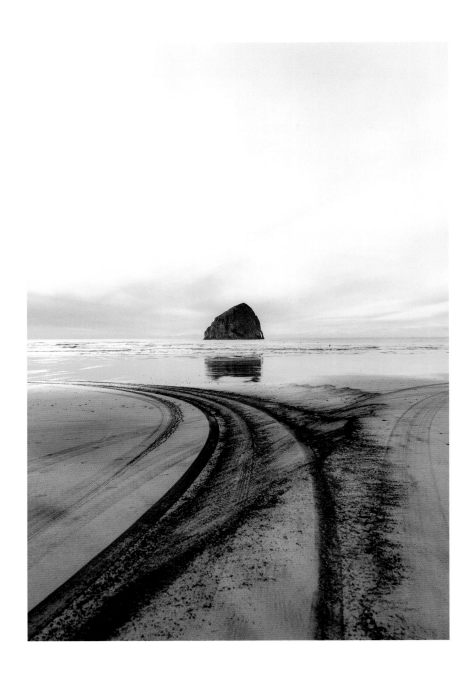

The whole experience was a blur. It is only now that I am able to look back on that experience and get a greater sense of where my heart was, and how I was processing everything. We went back to Portland trying to figure out how to have a relationship with my father, while knowing for the first time that he had known I existed my whole life but chose not to pursue a relationship.

Over the next ten months I was constantly battling whether or not I should go see him, but was terrified of taking up valuable hours with him—when he didn't have many left—away from the kids he actually raised. It didn't feel right for the "long lost son" to come in and dominate time with the dying father, whose battle with throat cancer was complicated and fraught.

That relationship was complex. So many layers, and so many walls I threw up to protect myself from getting hurt any more. He texted me on my birthday in 2017 and told me he loved me.

And that was the last time I heard from him. He died the morning of Father's Day that year—ten months from the first and only time I met him.

There is some good that has come out of my complex family dynamic: I have a beautifully full blueprint for what not to do. There are absolutely elements of my childhood and how I was raised that I would like to share with my kids when Madison and I have them—inspiring faith, teaching kids the value of hard work, showing them the absolute beauty of the natural world. I do have those examples.

But I have more examples of things I should avoid, do better, and try harder at than what was bestowed upon me. While that used to feel painful, after meeting my father, I can see that as a gift.

For years I never made any photographs of my family, out of fear of how to approach them. In part, I think I was scared of what emotions might resurface if I even tried. It wasn't until meeting my father, and then later, my sisters, that I saw the possibilities of stepping into this pursuit photographically. Day by day, month by month, inspiration started to reveal itself. I realized that I had to let myself go creatively. All of those previous experiences with family weren't things I needed to hide from.

Photography was the bridge to being able to use the negative emotions of my past in these delicate handpicked precious moments from my camera. The more I live life, the more I realize photography is about adapting to the ways in which life can change quickly. After all, life is happening to us, around us, every single minute of every single day. Finding those small moments, and capturing them, is wildly important for longevity in this space. Constantly growing, seeing new things, or old things in new ways.

In my opinion, this kind of approach is a major key to not getting burned out. And that's the beautiful thing about photography; once you learn the technical aspects of the craft, the highway is wide open for you. And I highly encourage you to change lanes photographically. Once I realized this, everything changed for me. It was like a veil being lifted and I could see life in front of me more clearly.

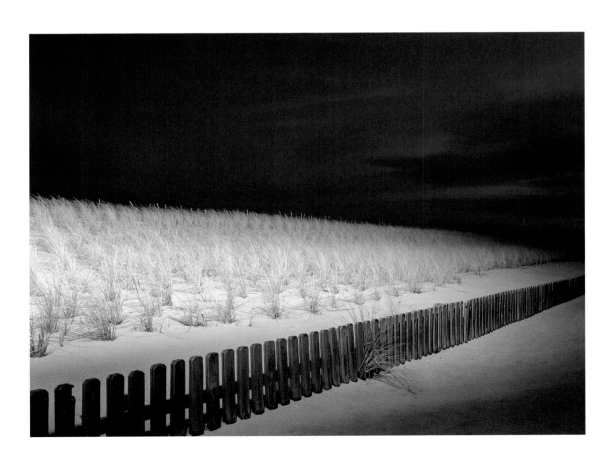

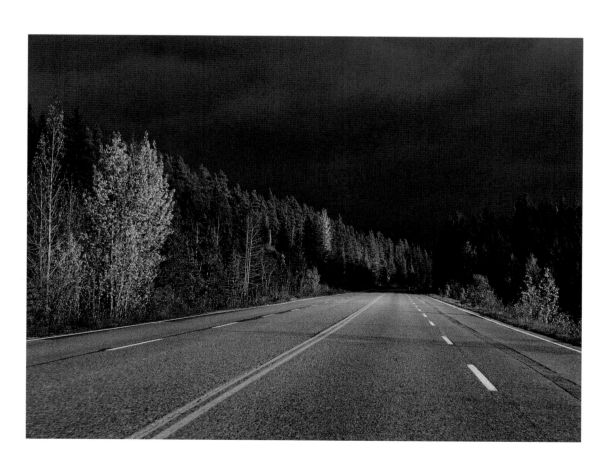

chapter 13

the light

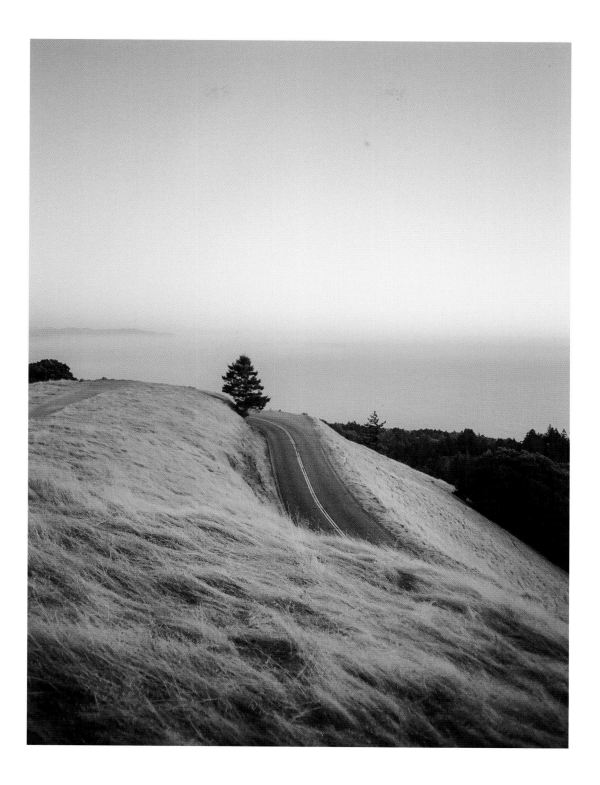

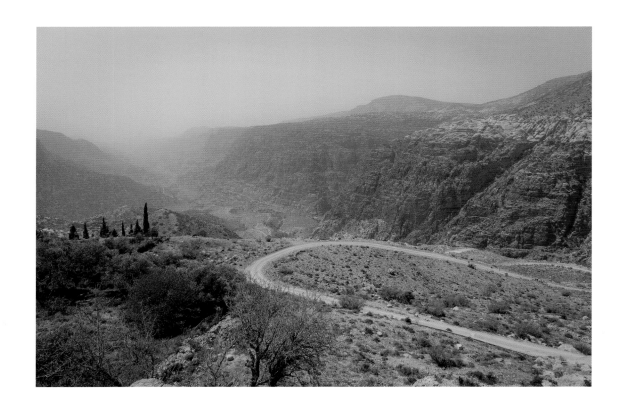

THOSE EARLY YEARS of marriage were some of the lightest and happiest years of my life. My photographs became lighter and brought me more joy, and I couldn't stop thinking about light. Finding a passion had in many ways changed my direction, and so the joy I was experiencing about my career only furthered my love for making photographs.

I started to draw close to those interactions on the street. Moments of laughter, love, and togetherness. It was a season where those things were so fresh on my mind and in my soul that it was second nature to recognize those moments when out making photographs. Getting the lifelong blessing to photograph Madison really started to open the chamber of my emotions. Before her, it had been photographing landscapes that brought me peace. Peace with myself and peace with God. It was such a place of comfort for me. When Madison came into my world it's like I got new eyes. I developed a new way to see. She helped these walls come down and opened me up more to express myself and see the raw, fragile emotions of human life. I think I began to feel things in a healthy way maybe for the first time in my life and I was focused on someone outside of myself. So I was able to see people and see their emotions for what felt like the first time. Truly.

Landscapes were really my introduction into photography. They were, and always will be, my first love. Part of the reason I gravitated toward them, I think, was the unfathomable sacredness of nature and vast spaces, and how they open a door for healing and beautiful self-discovery. Now, no matter how often I find myself photographing on the streets of whatever city or town I am in, or photographing my travels, landscapes still draw me in.

I believe this kind of freedom and healing happens because I am standing in awe of God's creativity in making the mountains, the oceans, the rivers, the valleys, the forests, and the deserts. This kind of craftsmanship and attention to detail always leaves me inspired and wanting more. To feel the cool ocean breeze rush across my face in Cape Kiwanda, Oregon. To hear absolute silence in the desert of Wadi Rum, Jordan. Or maybe it's feeling insignificantly small standing next to the scale of the Grand Teton mountain range in Wyoming. Whatever the moment or scenery, knowing that I was standing in the midst of God's handiwork offered some measure of peace.

Part of the peace comes from nature, but part is that chasing a landscape is intangible, right? There is a great sense of childlike excitement I get when I am rewarded with waking up at an ungodly hour to get myself in the

There is a great sense of childlike excitement I get when I am rewarded with waking up at an ungodly hour to get myself in the best position possible to photograph a sunrise.

best position possible to photograph a sunrise. Sometimes it is a bust but almost always it is rewarding. There is just something so empowering about waking up before your body wants you to and going after it. In getting up and hitting that alarm clock, there's no guarantee about what you'll see, just the hope it'll be good and worth the early wake-up time.

Since becoming a photographer full-time, I haven't stopped studying the way of light. The way light hits in the morning, and how it's incredibly different when it is hitting in the evening. The light from the morning sun often gives me a great sense of peace. Light and the absence of light affects a person's mood. Experiencing beautiful morning light usually sets the tone for the rest of the day. Evening light or that golden hour all photographers chase makes whatever you are photographing an honor and a delight.

And then there's the way light can be unexpected. The way light catches you by surprise. The way light can disappoint. The way light doesn't play favorites. Or the fact that light is unpredictable each and every day. No day is the same (well, unless you live in Los Angeles). I am constantly studying light in every setting that I find myself in. Light

Light keeps me curious.

still makes me stand in awe and wonder with how delicate and life-giving it can be to any given scene. Light keeps me curious.

And okay, maybe I'm geeking out about light, but photographers could not capture

the world in the ways we do without it. Still photography is consumed at an unbelievable rate in today's world. More photographs are being made each new year, especially as phone cameras keep getting better. So it is more important than ever to make photographs that count, ones that evoke emotion and give the viewer pause, even for a moment. It is what I am constantly looking for when I am behind that tiny little metal box.

Light has the ability to flood a room during the mornings—and to retreat at night. Light can change your mood in the mornings. A day with good light might inspire you to get out of bed and chase after a dream, just as a cloudy, overcast day might make you wish you could just stay in bed.

But another way to look at light is the spiritual parallels we see with scripture. Jesus often refers to Himslef as the "light," which is so valuable for people to see and understand as followers of Jesus. We first see Him apply this title to Himself in the Gospel of John as He states, "I am the *light* of the world. Whoever follows me will never walk in darkness, but will have the *light* of life." This passage and the way Jesus talked about light has been a massive source of encouragement for me through some of the darkest times.

I found faith at an early age and a formidable foundation was established. Even though my aunt and uncle were teaching me the way of Jesus daily as I started a new life with them and my cousins, darkness, manipulation, and unfaithfulness still creeped in. I don't take that as a knock on the teachings but understand that we are all human and we are all flawed.

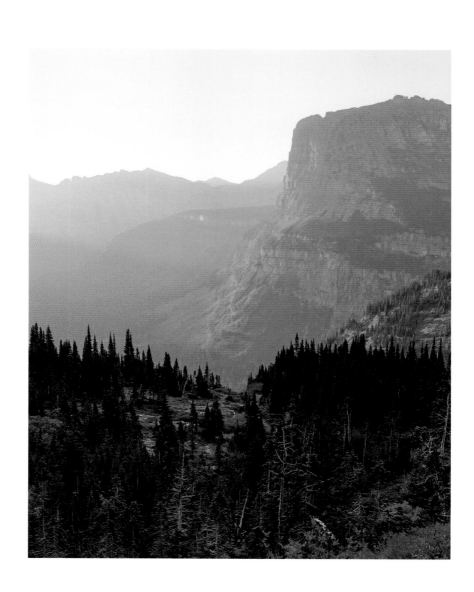

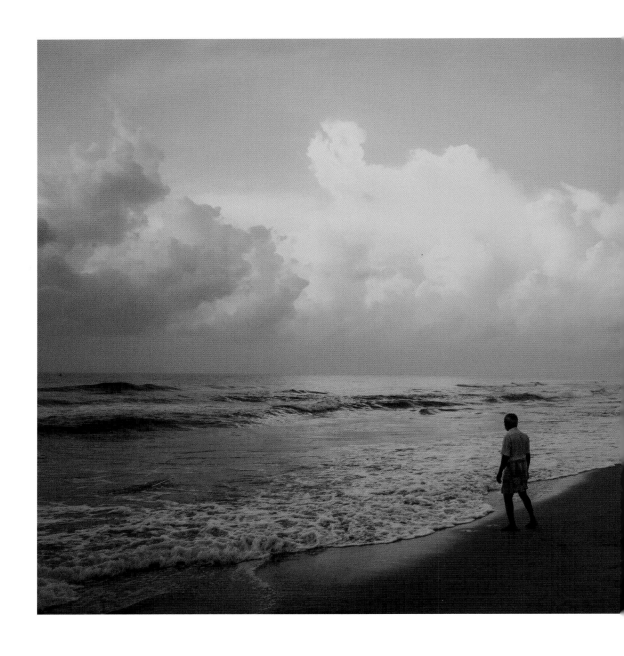

No one is perfect—faith requires us to be active in chasing the light. Stepping out of darkness and into the light.

The way Jesus was portrayed on the cross is seen as an act of radical love, something that humans—who are by nature against God—don't deserve. We didn't deserve to be in relationship with God, but He wanted to have a personal relationship with us. So God sent His only son, Jesus, to die in our place. But He didn't stay dead; three days later He rose from the grave proving that He truly is the son of God.

We didn't deserve to be in relationship with God, but He wanted to have a personal relationship with us.

When a person truly experiences that kind of love, it changes you. Faith and an enduring relationship with God have definitely changed me. And once I met Madison and married her, I was living for two. The more I could consider light, the more I wanted to let go. To forgive those who had hurt and wronged me, and find ways forward. Even though I had forgiven my aunt and uncle years before, I hadn't fully let go of those feelings of resentment, or fear, and when I did? I felt ten times lighter.

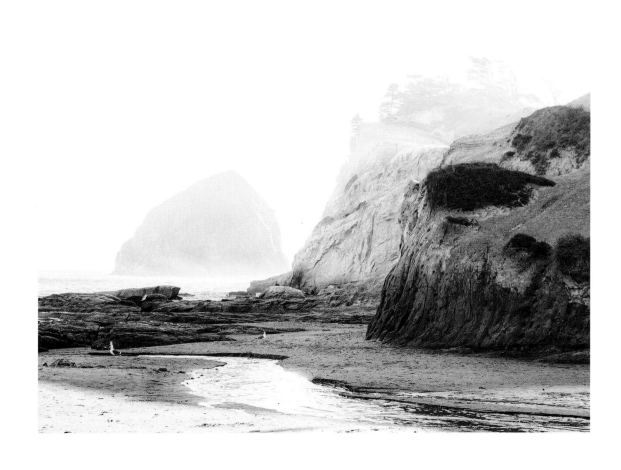

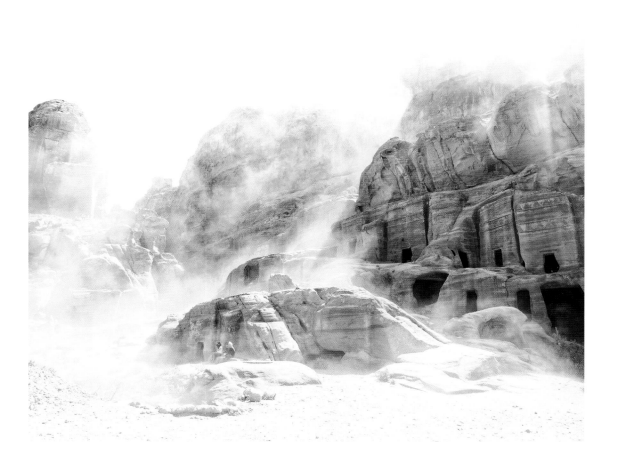

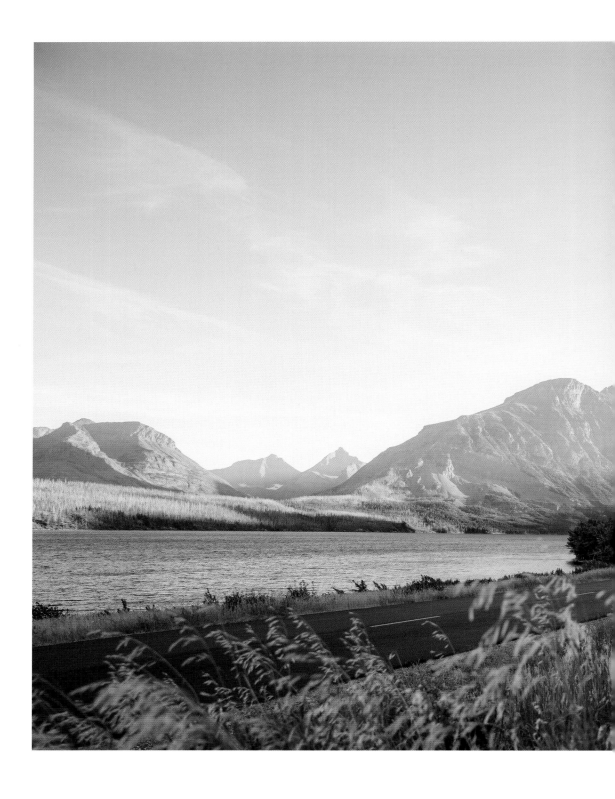

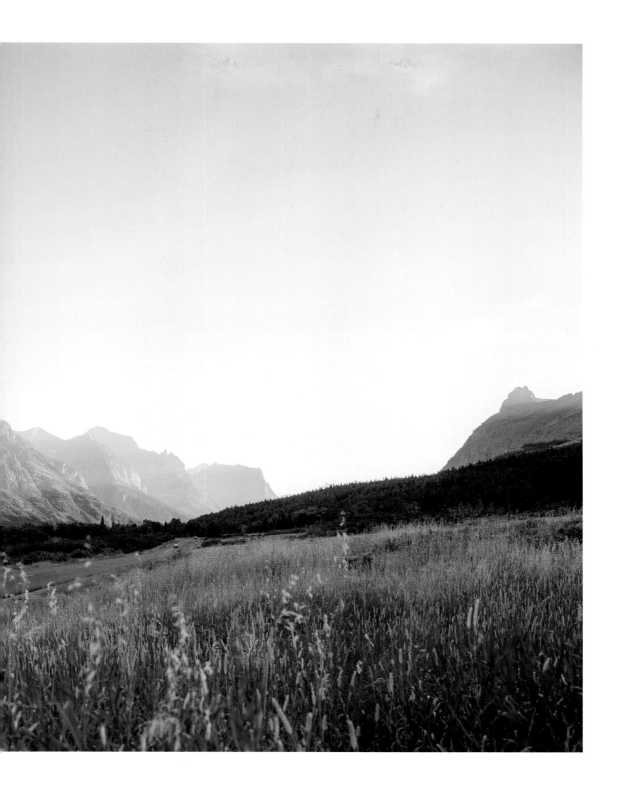

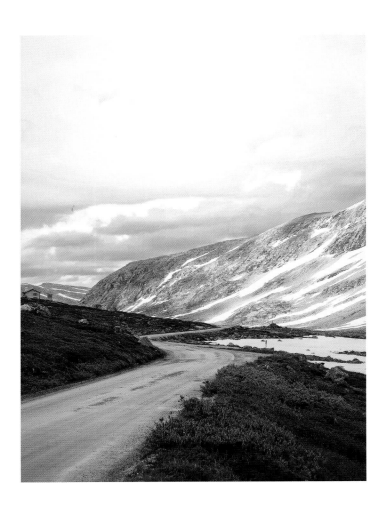

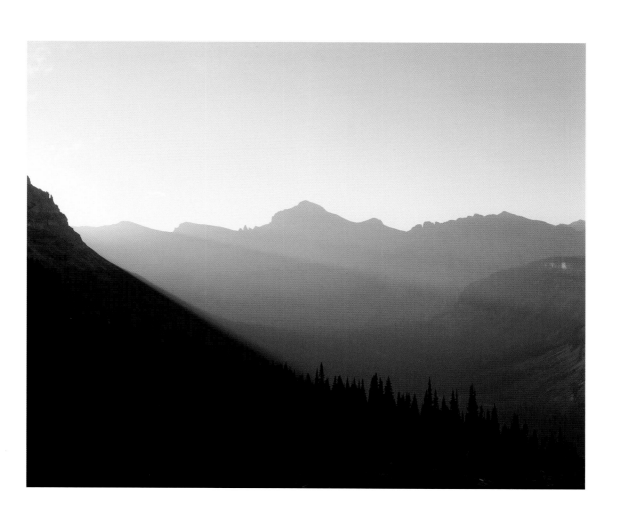

chapter 14

new york

AFTER SOME TIME in Portland, I learned the unfortunate news that the church had eliminated my role. Madison and I had been married for a couple years, and I had just turned twenty-eight. Even though I was disappointed, Madison and I saw it as an opportunity: We could move to New York. The east coast—and Manhattan in particular—had been a dream of ours, and with my sudden freedom because of being let go, I had to go full-time into freelance photography.

I wasn't ready; I was actually terrified.

I wasn't ready; I was actually terrified. Madison was also a freelancer so now we didn't have financial or medical security in case of emergencies. Still, the moment when we decided on New York, and on freelance, pulled us closer together and closer to God than ever before.

We found a tiny studio apartment on the Upper West Side, right at 75th and Broadway. It was only a few blocks from Central Park, and so we could spend mornings walking around before the noise of the city really set in. It was magical to feel like we had some part of Manhattan to ourselves.

During that first year our work started to pick up. Maddie signed with a New York–based talent agency right about the time we moved to New York. A lot of incredible job opportunities with content creation and fashion blogging came her way and made that initial transition amazing. Like we'd envisioned on our honeymoon, we were traveling the world together. Partners in business. I was Madison's personal photographer for all of her business opportunities working with some of the top fashion, clothing, and home goods brands, and she did a lot of modeling for me, to add a human element to a lot of my commercial work.

By the second year I felt comfortable: We were working regularly, we had friends. We had struggled to get our jobs up and running in the city, but we didn't regret moving to New York for a second. Our time in the city together created some of the favorite moments of our marriage.

Memories we'll carry together for life.

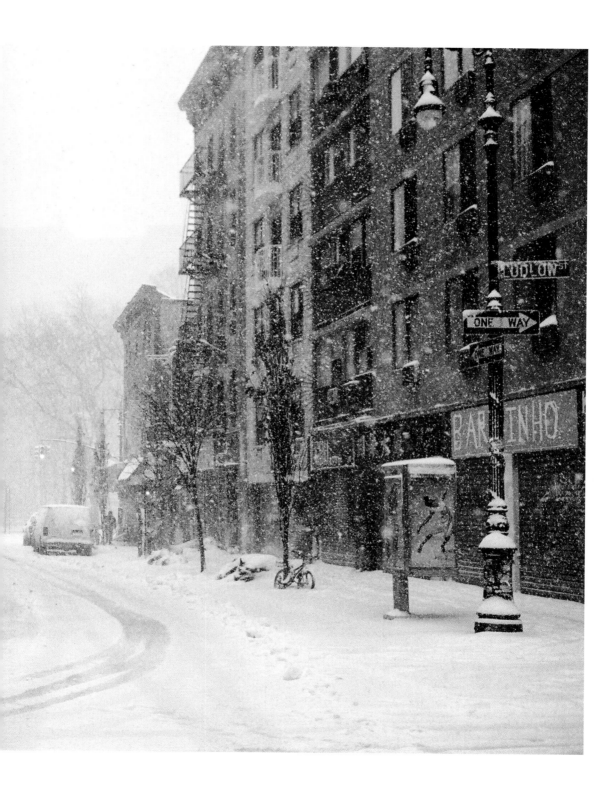

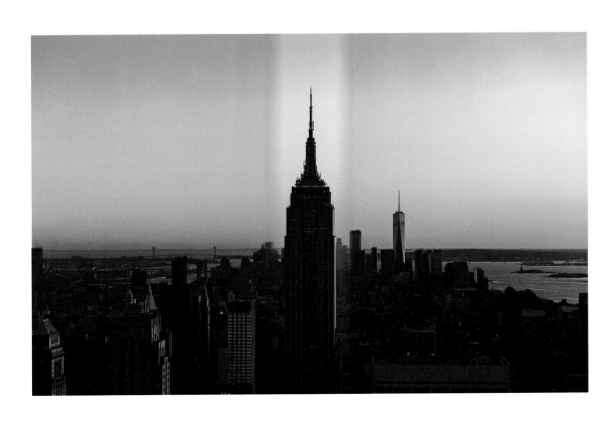

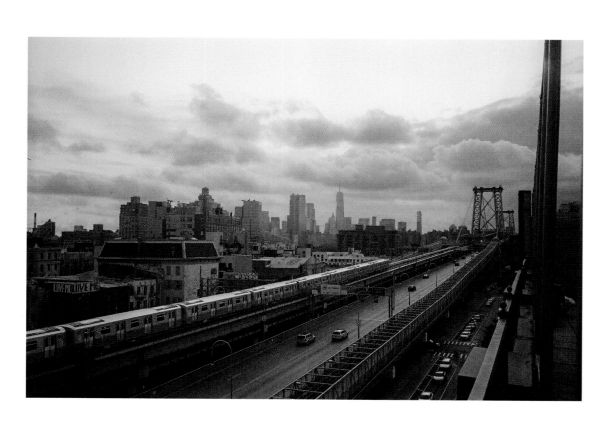

chapter 15

travel

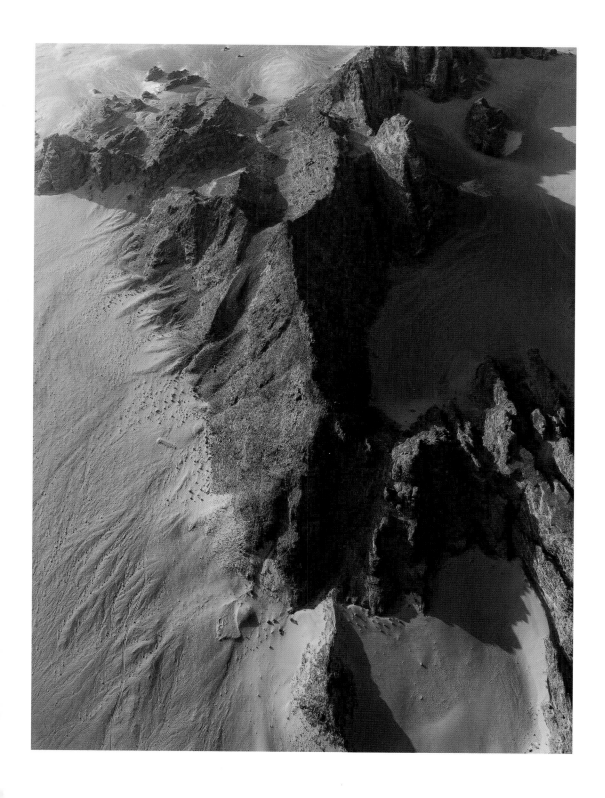

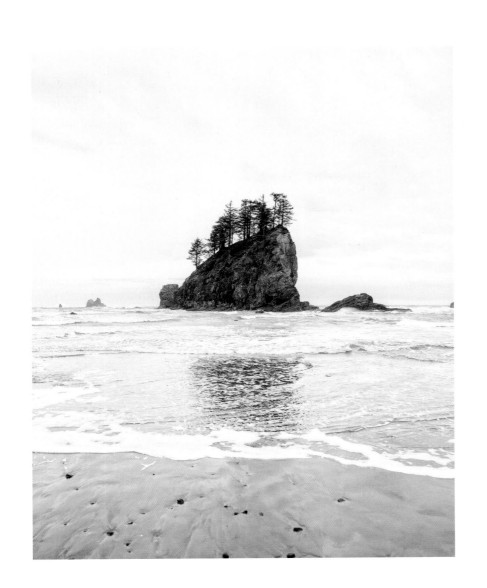

BECAUSE OF THE nature of our work and how it was developing, that move to New York also meant more and more travel. Sometimes alone, sometimes together, sometimes for work, and sometimes not.

Kids from my town rarely leave the state of Florida. But my mother had instilled a curiosity in me early on, one that made me always hungry to see *more*. My international travels didn't really start until I married Madison in Iceland—but after that I was hooked.

There is something so beautiful about being able to experience a different country, culture, language, cuisine, and energy than the one you know and are familiar with. Those experiences taught me so much about myself, and helped expand my mind and understanding of how beautiful and creative humans are.

During our first year of marriage I had the opportunity to go to Israel twice. Which, as a Christian, was a dream. I got to visit the very places where the accounts and stories in the Bible took place. To walk the roads Jesus walked, to visit the locations of biblical stories I'd been reading my whole life.

Not long after that I was booked on a job by the tourism board for Jordan, which is one of the most beautiful countries I've ever seen.

Another beautiful part of travel is being able to experience it with the people that you love. For me, getting to share these joys with Madison ended up making some of my most precious and favorite memories with her. There is a great sense of vulnerability stepping into a radically unfamiliar space. And it's funny, because we did that in committing our lives to each other, and in uprooting our lives to New York. But travel became a new way of embracing the unknown.

No matter the country or city I've been to, I have been met with great kindness and open arms. There have been times when I was just walking down the street with my camera and was invited into someone's home. Once, in India, a mother saw my camera around my neck and then ushered me inside to show me her photographs of her parents on the wall. Completely unable to speak each other's language, the photographs were a common bond that broke that barrier.

Then there was a time in Cuba, when I heard what sounded like dancing from the street. I peeked my head through the door and was instantly met with loud cheers and invitations to come dance with them. That kind of love is just so inspiring.

That kind of love is just so inspiring.

We've been lucky to travel all over the world—including the Czech Republic, Ireland, Sardinia, England, Thailand, Myanmar, New Zealand, Kenya, Argentina, and Norway. We've made memories and photographs in all of those locations, but one of the biggest blessings has been the reminder of humanity's inherent good.

I have dreams of where we'll go next. The DeKalaita side of my family is indigenous to the southeast region of Turkey, and I want to explore those Assyrian roots more. In my travels, I often think back to that night in Cuba, surrounded by neighbors and dancing on the street. I know that my mom, were she alive, would have been right there and dancing with me.

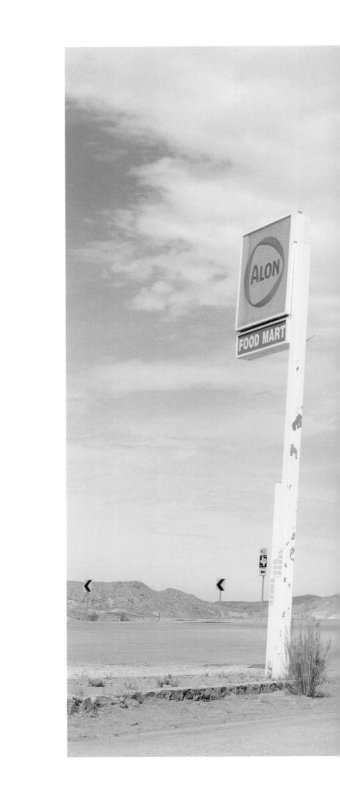

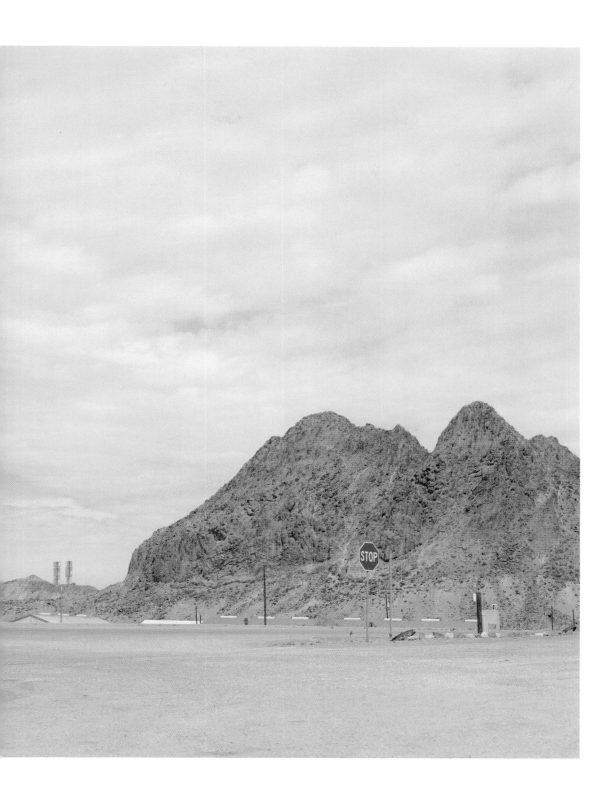

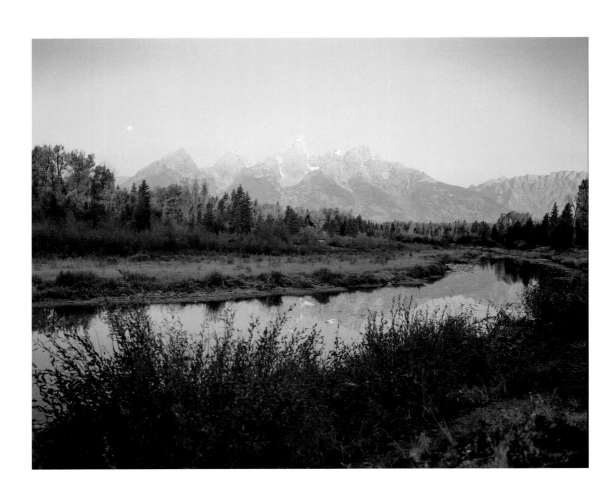

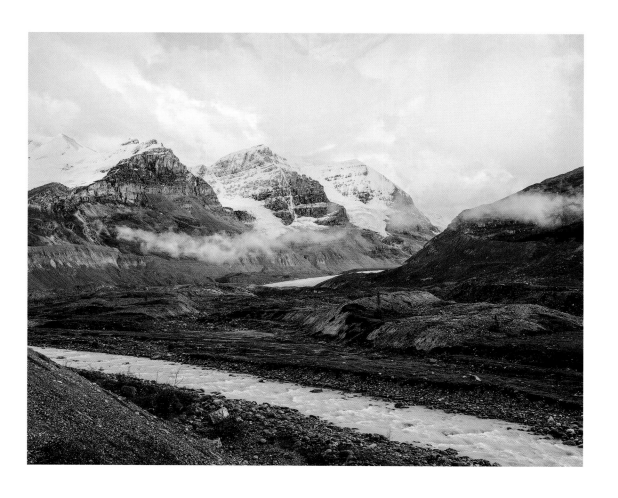

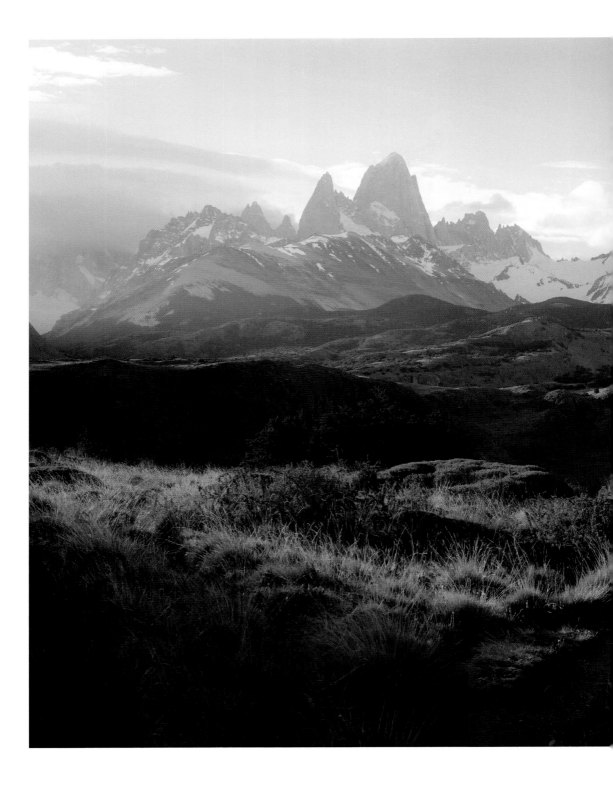

chapter 16

hannah

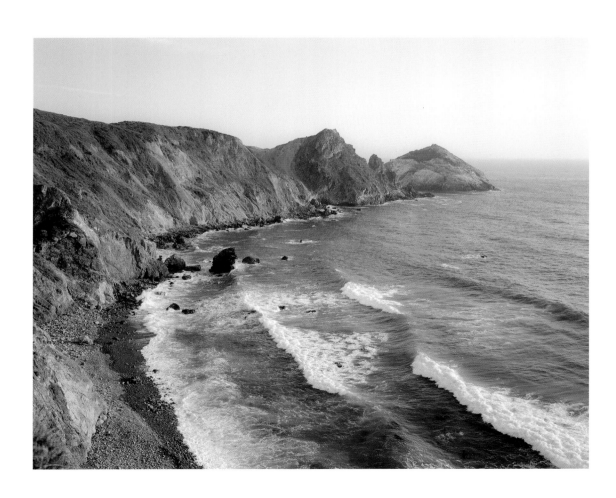

WHETHER WE ARE traveling together or apart, I'm always able to lean on Madison during any periods of hardship. She's my rock. And that is exactly what she was for me during the most shocking and heartbreaking experience of my adult life.

Early on July 4, 2019, I woke up to my phone buzzing. There were so many missed calls and text messages, all telling me to call my brother Nick back as soon as possible.

Something was really wrong.

My heart started to pound, and I got out of the bed and went into the living room to call him. Nick immediately broke down and could

Something was really wrong.

barely get through the words as I was trying to calm him down. I was asking him what happened, only to have the air completely knocked out of me when he told me our sister Hannah died in a house fire in the early morning. Just three hours before that phone call.

I haven't had many out-of-body experiences in my life but I'm pretty sure what I felt in that moment is something I hope I will never have to feel again. I was in shock, my whole body was cold and hot and totally frozen. I couldn't believe what I was hearing.

There had been a storm that evening in Inglis. Lightning struck a power line pole by our old house and that blew out the power box. The impact ignited all of the wires in the house, starting a massive fire. My uncle, cousin, and family friend all made it out of the house, but in

leaving, they didn't realize Hannah was still in the house since she had recently started taking on night shifts at the hospital. They tried to save her by putting up a ladder to the second floor, but the smoke was so aggressive they couldn't stay up there long. It didn't work.

Hannah did not make it out. We found out later that she was the one who had called 911 first and it was somewhat but not really comforting to know that because of all the toxic smoke that was in her room, she went down during the call and left this earth before a single flame touched her body.

After hanging up with Nick, I bought the next flight out of New York to Tampa. I was going home. This week of being back in my hometown with all of my siblings to say our goodbyes to our little Hannah Michelle still feels like a blur.

Grief looks different for everyone. And as I have learned over the last two years since we lost her, it comes in waves. At least for me. There are memories I have of Hannah that sometimes act as triggers when an action, color, or physical object from these memories appears in my present life. I won't expect it. Sometimes I cry, sometimes I laugh as I remember how sassy she would always be. All of my siblings handled the grief differently, but we all felt it so deeply.

Hannah was confident. Proud of her siblings. Always put others before herself, which I think is a testament of her soul and calling in her life as a nurse. My sister Rachel and I always say this when we talk about Hannah, that she was the best of all of us.

During that week in Florida, we prepared for the service and mostly just tried to keep our

heads above water. Rachel and Sarah were going through some of Hannah's belongings in her storage container. The first box, front and center, held a journal of Hannah's that was put there when she moved six months earlier. In that journal they found letters: one said Mom, then Dad, one said Sisters, another Brothers (which was blank), and then the last letter was to God.

In that letter she wrote how thankful she was for the life He had blessed her with and then mentioned how she had reached a peace in life, that she was ready to be called home to heaven. When I read this, I was in shock. I mean first off, there are so many theological layers to this that kept me up for hours in the following weeks. But this letter, in a time where we were trying to keep afloat, gave us a small measure of peace.

Hannah had been ready to go home. Even though she had her entire life ahead of her at the tender age of twenty-six, and her life was just beginning. None of it made sense. And in the immediate aftermath, I wrestled more with God than ever before. I came to feel, with Maddie's help, that as hard as losing Hannah was, and how much I wanted to be angry at someone or something—I couldn't direct that anger toward God. What I read about in the scriptures and everything I learned in Bible college came rushing through to me to remind me that she is in no pain now. That she is in the presence of God, where fear, shame, guilt, anger, and death know no name.

After the funeral, Maddie and I returned to New York. The rest of summer and fall of 2019 I didn't really know what to do or how to just go on working. Whether I was photo-graphing the streets or traveling for work, a return to normal life didn't feel possible. There was a void, and that could not be filled.

I knew that with time in some ways the pain would get easier to manage. The void would never go away, and neither would the grief, but right after Hannah's death I couldn't focus the way I used to. So while I had a few jobs here and there, I turned my focus to nothing but hitting the streets of New York. I was able to escape with my thoughts and pain. Just take my camera and a few rolls of film and walk out my door. To try and feel something else. Anything else. The streets gave me that, photography gave me that. I was able to fully and purely lose myself in the masses. Unnoticed and unbothered. I was walking miles and miles, focused for hours on moments with strangers.

Two months after Hannah's death, Madison and I went back to Iceland to celebrate our fourth anniversary. During that time I was pho-tographing the endless and vast landscapes of Iceland. Being there, in the place we exchanged our vows four years before, it finally felt like a part of life was returning to me. After every exposure I make I'm slowly becoming myself again. This, in a strange way, was a form of healing for me during the months right after Hannah's death. It was a place for me to go to hide if I felt like hiding that day or embrace all the messiness and use that as fuel when I am behind the lens. To tap into that deep well of emotion. Whenever I felt down I thought of Hannah: How would she want me to see the world? She was in all of those photographs, every mountain, every lake, every miraculous thing. And I will continue to carry her through-out my art forevermore.

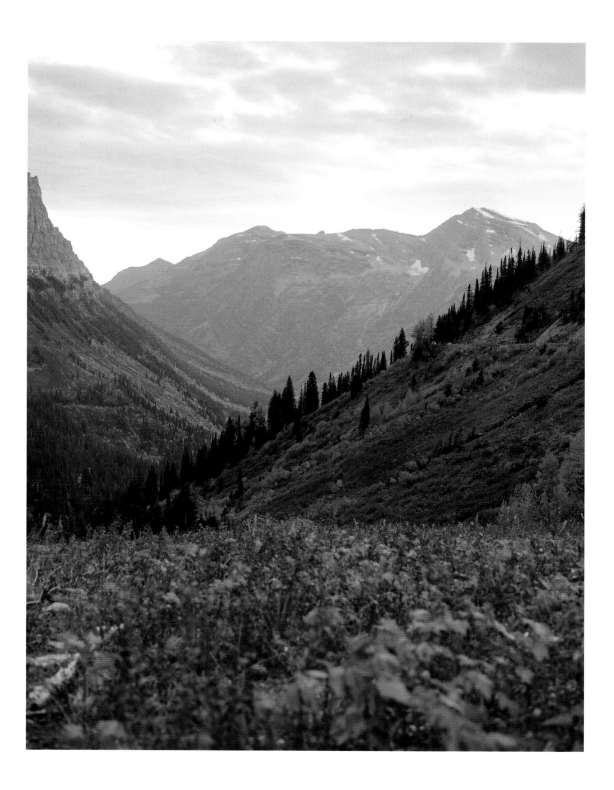

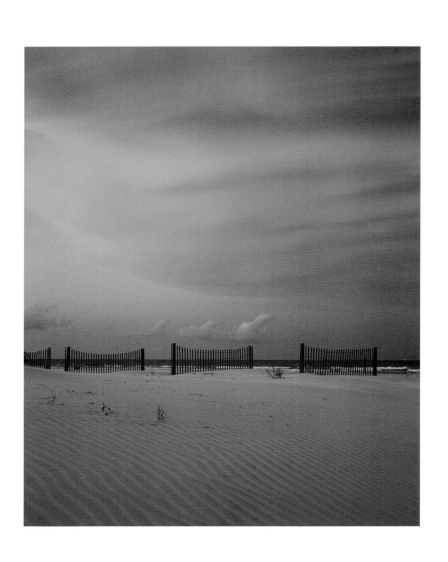

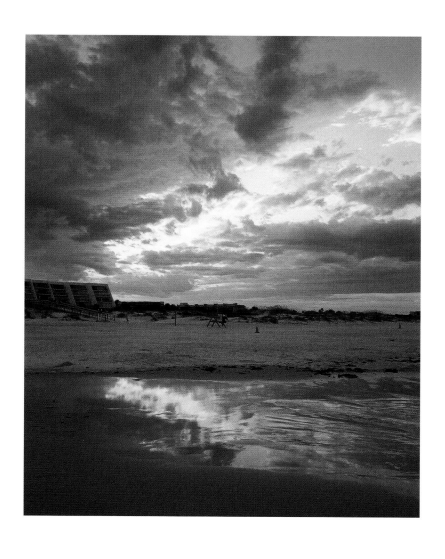

chapter 17

home

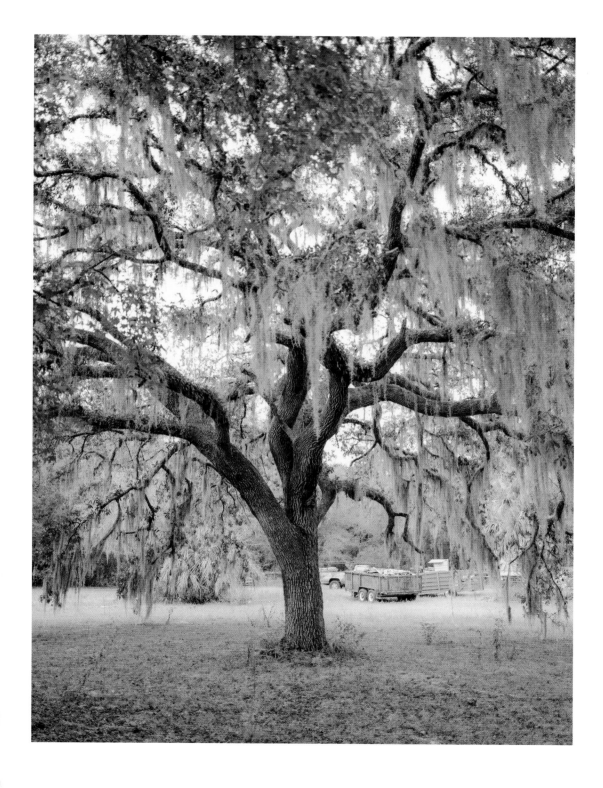

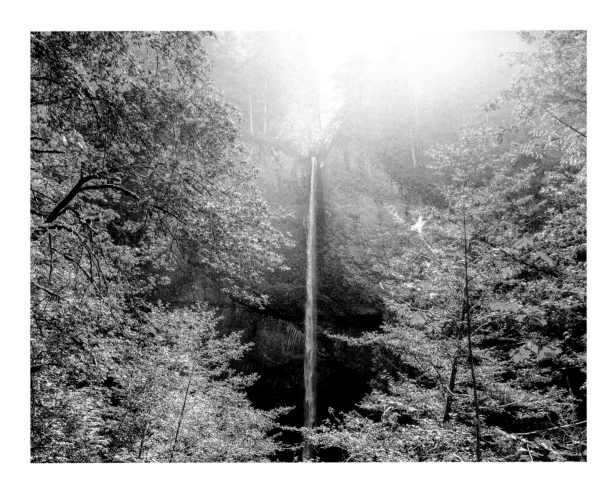

NASHVILLE HAD ALWAYS been the end game, something Madison and I talked back-and-forth about on vacations. It actually took me the first four years of our marriage to warm up to the idea of living in Nashville. But Madison stayed persistent. She would tell me about her vision for the plot of land where we'd build our home, the lawn where our kids would play. Knowing that Nashville was common ground, it meant we would be near all of her family and the majority of my family. Even my sister Laura, whom I met on *Relative Race*, moved her family from upstate New York to Nashville a year before we did, knowing that Nashville was going to be the landing spot for us eventually.

We were visiting Tennessee in March of 2020 when the coronavirus shutdown began, and decided we ought to stay with her parents for a few months rather than return to our apartment in Brooklyn. As time passed, we began to wonder whether we should stay. Work had slowly ground to a halt for both of us, and while we tried to stay hopeful, we

Work had slowly ground to a halt for both of us, and while we tried to stay hopeful, we found the most joy in leaning on family, and on each other.

found the most joy in leaning on family, and on each other. And so ultimately we decided to give up the Brooklyn apartment and start our lives in Nashville a few years earlier than we had envisioned.

In a year when everything felt out of control, we tried to find delight in the simple things. Without much commercial work on my plate, I focused on portraiture and gentle landscapes. I realized that, if I had been traveling for work, I would have missed the chance to photograph the early-morning fog pluming off the ground in our town. I wouldn't have returned to my love of distance running, or turned my focus to quieter scenes in nature.

Despite what the world looked like, staying home inspired so much gratitude. In some ways, it reminded me of my early days in college, chasing the sunrise and just shooting for the joy of it.

When we first got to Nashville, we experienced this immediate shift in lifestyle. With lockdown and our new home, there was a shift of focus and a shift in our priorities. It was an opportunity to reconnect, build on my relationships with family, including my aunt. And I knew that personally it was time for me to focus more on my health, as it had started to slip a lot after Hannah's passing.

It was a time when getting away and finding new landscapes would be impossible, but there were other opportunities for growth. Whether that was through running or by pushing myself to new creative spaces in photography, we began to explore the not-so-new town we would call home. Rediscovering running proved to be an adventure and an escape. Back in the day,

During my running, I began to see more— or rather, started to see *better*.

running for school, it had been a group activity that sometimes trended solitary; in Nashville, I began running with Madison, but more often I ran alone. Even rediscovering it in my thirties was peaceful, healing. All that time in New York, and I'd forgotten how much I loved tromping through woods or around a track, how *whole* it made me feel.

During my running, I began to see more— or rather, started to see *better*. Spots that I'd overlooked during past visits to Nashville became newly beautiful. Those were the places that I would take our children, where Maddie and I would celebrate all of the anniversaries to come. The place where we could return to when one day we were able to travel again.

We were homebound, and yet we were growing. It was a time to pray, a time to work out frustrations, a time to be pushed. A time to see progress.

Sometimes, during those mornings, I would take photographs. There was one day in particular when the whole sky was overcast, gray, and so foggy I couldn't see more than a few feet in front of me. It wasn't a vast, epic landscape, but it was quietly better. If I hadn't stopped, I would have missed it. I wouldn't have seen the lay of the land.

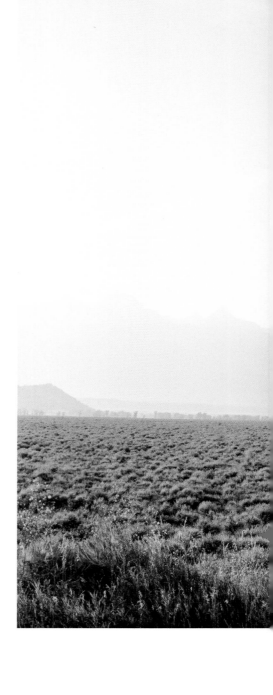

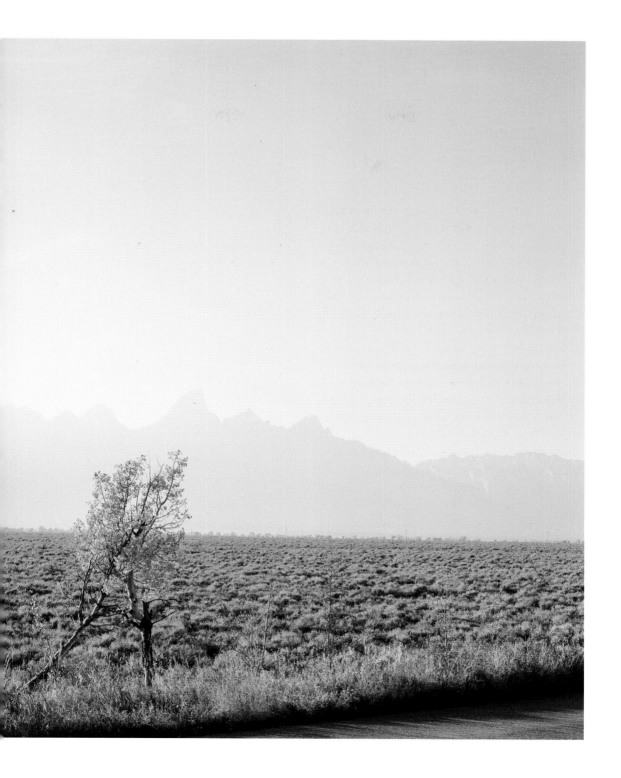

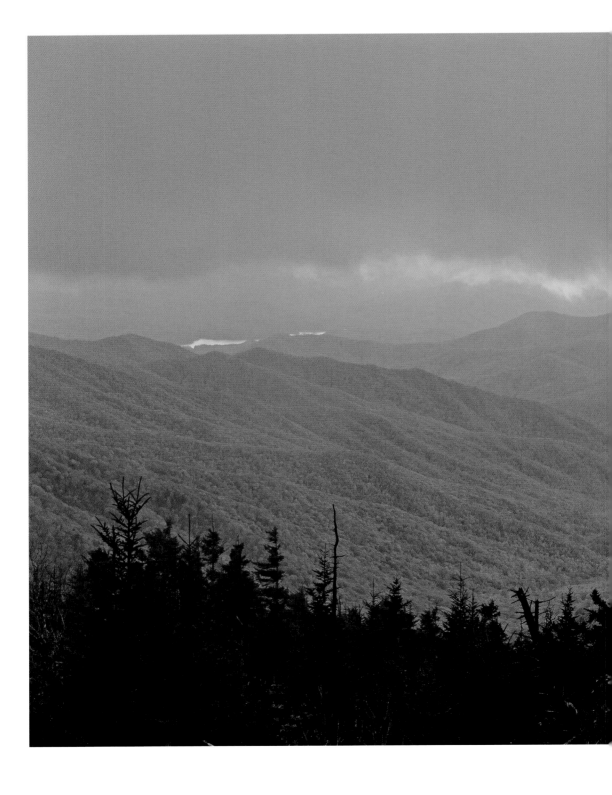

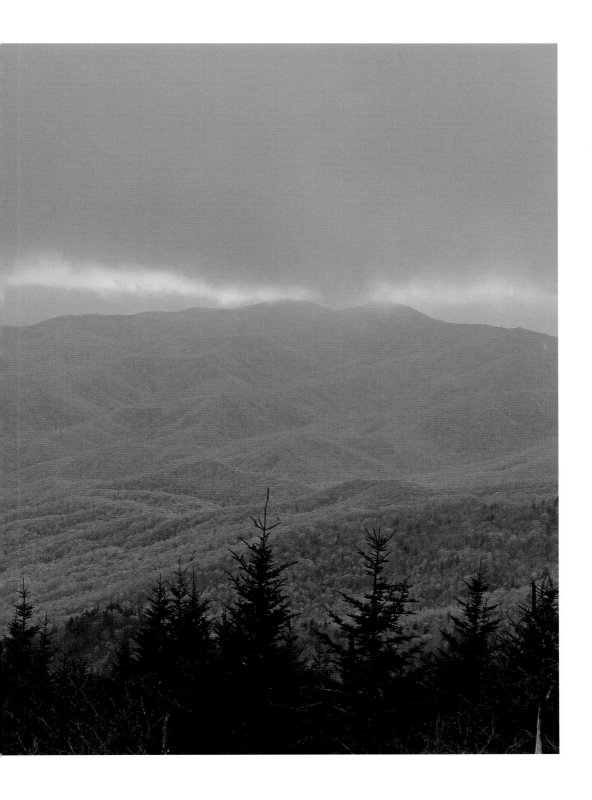

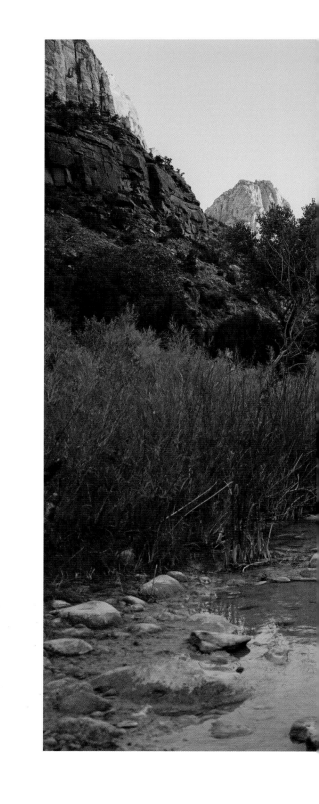

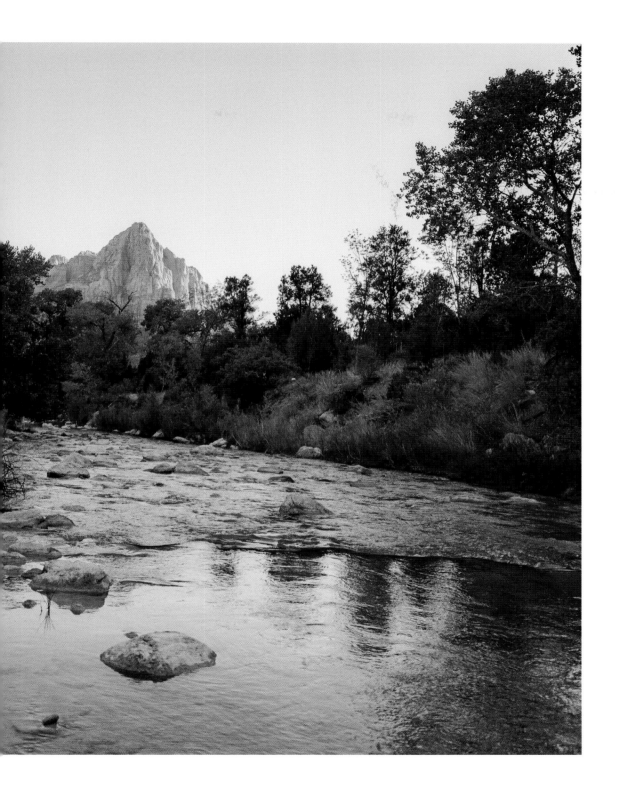

conclusion

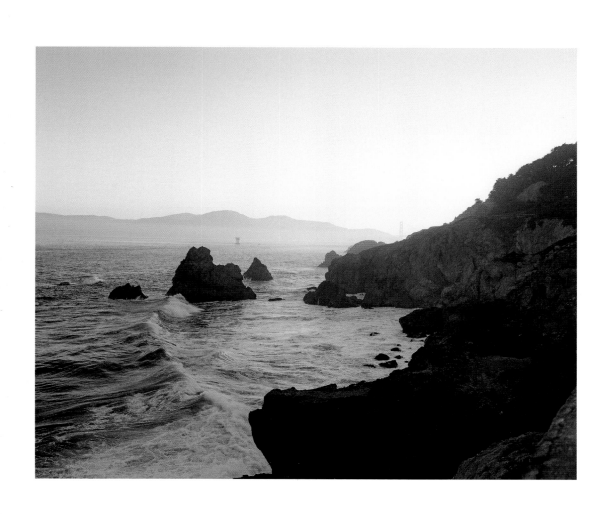

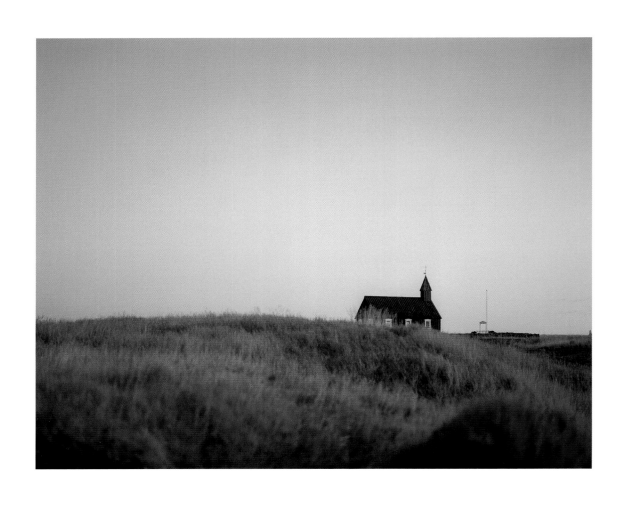

WITH EVERY SEASON comes challenges. My journey to becoming a photographer hasn't been without struggle, after a childhood full of difficulties.

One of the spiritual gifts of the Christian belief is faith, and I believe I have this gift. With all the chaos, heartbreak, death, and tragedy that has been a part of my journey thus far, my faith in God has never left me. God has felt near. Even if at times, I could not sense His nearness, I still believed He was near. And I say that I believe that I have this gift because nothing else makes sense. To be where I am in my life having gone through everything, I am still here. Still alive. Still well, still curious and chasing light. With the beautiful guidance of mentors placed in my life throughout the years acting as fathers, mothers, brothers, and sisters was no happenstance. It is my sincerest belief that God's hand has been on me since the beginning.

In a world where there is so much ugliness and darkness it is my greatest blessing to be able to share that light with others. In writing this book, my intent has never been to hurt people who misunderstood me, but to help others who have gone through similar things, and to inspire people to take that leap of faith, to pursue that passion.

The beauty is that everything you experience will become part of your process—the good, the bad, the ugly. My life is embedded into each photograph I take, and what I've experienced is a big part of how I now perceive beauty and try to capture it on film. Whether I'm making portraits of my wife or honing in on some gorgeous landscape, I'm still bringing my own experience to that shot. Whatever your art is, you can do the same.

I look back on my college self running around and chasing sunsets, and I love how pure that joy was, how inspired I was to seek beauty. If I look even further back, there's a high school–era Joe running around in the heat of central Florida, trying to figure out what he wanted. Looking even further back, I see a kid asking all sorts of questions. That kid didn't know what kind of beauty was out there.

I've had my mother's curiosity from the beginning, and from what I have heard about my father, I have his curiosity as well. He got out of his small town in Alabama and traveled the world, and in that way I think we're pretty similar. But it wasn't until photography that I was able to really channel the curiosity in a way that felt right.

Learning that has allowed me to get past the human impulse to crave newness and success. It's natural, right? We want to be successful in whatever we're passionate about.

For years, I've struggled against that unnecessary impulse to just chase numbers. The effects of social media have a way of blurring passion into background noise, but the way I've come to think of it is that social media is a way of showing the world what *you* love. For me, becoming known online meant that I was able to find the love of my life, a career that fulfills, lifelong friends. But even if it hadn't turned out that way, I believe I'd love photography regardless.

That's the way of it, anyway. Circumstances can change, meaning that jobs and income aren't stable or guaranteed. If your success is

measured by how others perceive you, your passion won't be about passion anymore so much as it is about recognition. That's not the way to do it.

After all, photography can be seen as a static art, but it isn't. I love that what I capture—and what anyone can capture—is a moment of beauty in this constantly evolving world. It's meant everything for me to meditate on those small moments, and capture them frame by frame.

I hope my story encourages you to trust the process. To keep moving. To keep making photographs, or pursuing whatever your art form is. We all have to start somewhere. And I've learned that that beginning isn't something we should be embarrassed about. It will always have the power to encourage us. It has done that for me countless times. There is so much to learn from our earliest work. That's why I keep mine up, so that I can return to it as I keep telling my story.

For me, photography is about creating and capturing life as we see it, which is so much more than the click of the shutter button. But each photograph really does come down to a split second when you decide to freeze that moment in time, and allow others to experience it with you. You ask yourself what the story is that you want to tell, and let the rest unfold: *Click.*

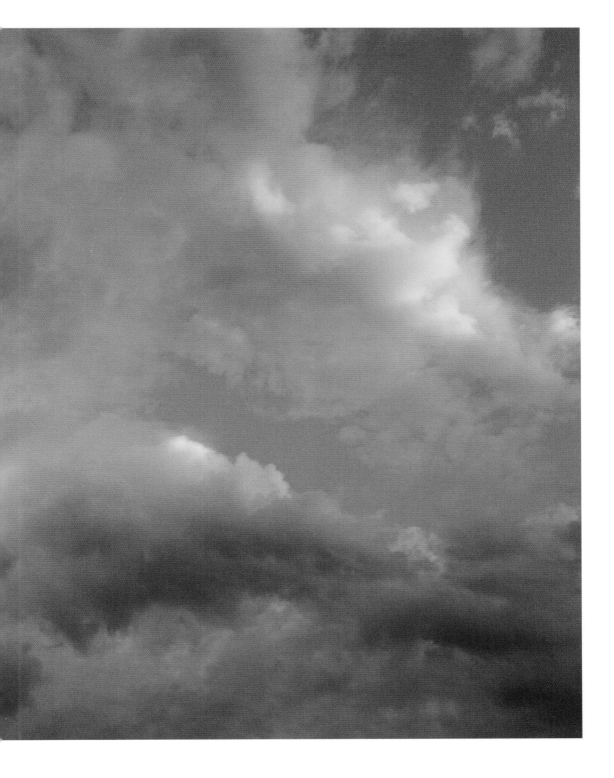

acknowledgments

I WANT TO thank my wife, Madison, for being a constant source of inspiration, love, and support. This body of work, and everything else, would not have been possible without you. Here's to many more years of memories and beautiful chaos. I love you.

I want to thank my siblings, Rachel, Sarah, Nick, Jacob, Laura, Katy, and Carisa. You all have massively and uniquely impacted my life as a brother, man, and artist. I hope this book makes you proud. Could not have made it without your support. To my adoptive mother and aunt, for taking me in as your own. I am thankful for your strength and for staying strong when it wasn't always easy. Looking back now as an adult, I can see how I get a lot of that from you. And to Hannah, we all love you, miss you, talk about you, and think of you every day. Your zest for life and beautiful personality continue to be my driving force of inspiration. Being your brother has been the greatest honor of my life.

Huge thank-you to my editor, Anna Montague, for countless hours of talking, editing, and all the back and forth to create something beautiful on these pages. You brought the book to life, and I could not imagine doing this with any other editor. Thank you for believing in my story, and encouraging me to write it (still can't believe you convinced me to write 20,000+ words). Big thanks to the amazing team at HarperCollins: Lynne Yeamans, Amanda Janes Jones, Marta Schooler, Tom Hopke, Kate D'Esmond, Andrew Jacobs, and Suzette Lam.

Big thank-you to my manager and friend, Ernesto. One of the better things to happen in my career was meeting you and your wanting to take a chance in helping me grow in my business and career. You have done that, and

more. Thank you for being the coolest and hippest fifty-year-old I know—absolute goals.

Massive thank-you to my close friends. You all have been there for me through the ups and the downs, and are a constant source of inspiration for me. Love you all so much: Cory, Corey, Matthias, Ian, Sarah, Jimmy, Dustin, Paul, Andrew, Janice, Allie, Andy, Andre, Filmore, Willem, Matt, Gabe, Jeremy, Dan, Dhreeraj, Cubby, Danny, Bijan, Gabriel, Emily, Bram, Adrian, and Wes.

A big part of this work was done in the memory of my mother, Nikkianne DeKalaita. I wish you could have seen me grow up into the man I am today, have met Madison, and just been a part of our daily lives. Your love still inspires me every day. And I hope it makes you proud to know that I plan to change my last name back to DeKalaita. It's in our blood.

To my father, whom I met only once in my late twenties: I am so thankful to have met you when I did. I am thankful for your transparency and vulnerability and letting me get to know you. You led me to meeting my half-sisters, which was one of the best things you could have given me.

I also want to thank Madison's parents, Bill and Tena Bosworth. I sincerely lucked out and was blessed with the greatest set of in-laws. Thank you for believing in me and trusting me to spend my life with your incredible daughter. Your inclusion of me into your family was something initially I didn't know that I needed. So thankful to be a part of this wild family.

And last but not least . . . over the last ten years I have had the great honor to get to know many of the people who have been following and engaging with my photography. I literally would not be where I am in my career without your support. Forever grateful.

ABOUT THE AUTHOR

Born in Michigan and raised in Florida, Joe Greer has been making photographs ever since he went to college in Spokane, Washington. Since going freelance, he has been able to pursue his passion for photography and travel the world. He has lived in Colorado, Oregon, and New York, and along the way has worked for companies including Apple and VSCO. Now, he and his wife, Madison—along with their dog, Crosby—live in Nashville, Tennessee.